The State and The Arts

Edited by John Pick

First Published 1980

Copyright © City University, Centre for Arts

ISBN 0 903931 30 3

CITY ARTS SERIES
General Editor: John Pick

John Offord (Publications) Ltd.,
P.O. Box 64, Eastbourne, East Sussex.

Printed by Eastbourne Printers Ltd.

The Arts Council of Great Britain operates under a Royal Charter (granted in 1967) in which its objects are stated as:

1 To develop and improve the knowledge, understanding and practice of the arts.
2 To increase the accessibility of the arts to the public throughout Great Britain.
3 To advise and co-operate with Departments of Government, local authorities and other bodies on any matters concerned, whether directly or indirectly, with the foregoing objects.

Currently the Council assists more than a thousand 'clients' by grant aid.

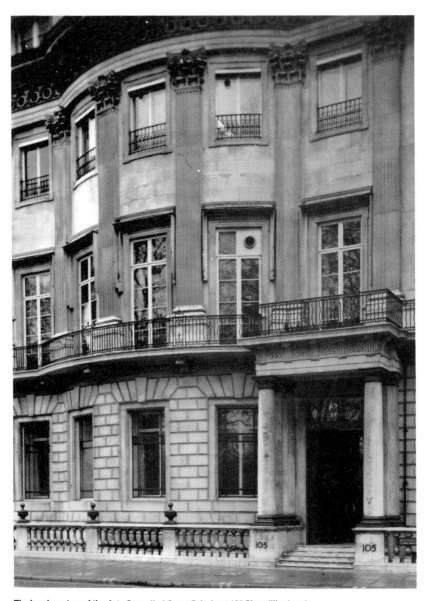

The headquarters of the Arts Council of Great Britain at 105 Piccadilly, London.

Preface

The writers of the main essays in this book are men with long experience of the Arts Council, and they have understood its ways. Their views however are of course their own and do not represent any kind of official opinion.

I should like to thank all the contributors for undertaking a task which, in the event, proved harder than we expected. It is not easy to find the right words to describe the movements in policy and changes in technique that the Council has adopted - yesterday's rallying cry often sounds patronising or empty, and the vital battles of a decade ago have a way of seeming dull and irrelevent today. Nor was it easy to find some of the information; an astonishing amount of the administrative record of the last thirty-five years no longer exists, and if it serves no other purpose this book may well urge us to keep the information that we have, and thus keep a record of one of the most extraordinary periods of our cultural history.

Particularly I should like to thank Tony Field, Finance Officer of the Arts Council, for his help over the names of Council Officers, Rod Fisher for much direct and indirect help, Sue Rose for photographs and N. V. Linklater for his dogged pursuit of the figures that appear both as tables in his essay and as an appendix to the book. In that respect we owe particular thanks to the staff at Birmingham, Bristol, Colchester, Leatherhead, Nottingham, Salisbury and Sheffield for their patient help and their kindness in allowing us to use their records. To my colleague Peter Stark I am grateful for drawing my attention to figures of overall government spending on the arts, and to Michael Quine for kindly allowing me to use his summary of administrative costs which appears as an appendix to the text. To John Offord all of us owe much gratitude for his patient and professional help.

John Pick

City University 1980

Illustrations

CONTENTS

INTRODUCTION: THE BEST FOR THE MOST

John Pick

The creation of the Arts Council was, like so many of its activities since, wreathed in a certain mystery. The decision to continue the war-time Council for the Encouragement of Music and the Arts[1] into peace-time under another name was taken by a small group of people, near to Government but not in it, of widely different interests, bound only by a common belief that what they were doing was enlightened, public spirit-ed and a necessary part of a Welfare State.

It was an astonishing time for Britain to begin wholesale financial support of the Arts. In vain throughout the nineteenth century and through the first forty years of this one had the theatre managements and the musical entrepreneurs argued for such help. Grudgingly there had been occasional assistance given to the purchase and support of the great collections in the visual arts - led, significantly enough, by Prince Albert, who came from a German background in which support was the obvious duty of the State - but even in that field money had been scarce and much of the support restrictive and unenlightened. Although at the turn of the century Britain ruled a third of the globe, was arguably the wealthiest nation on earth, and had traditions in the popular and the 'high' arts which were as rich as those of any other people, the formation of a national body to dispense the public funds in support of the arts was scarcely entertained by government. Yet it was hardly a new idea; many voices in the nineteenth century had argued that a rich new industrial state could easily take over the patronage formerly exercised by the Church, and by a few rich men. A hundred years previously Martin Archer Shee had asserted:

> 'A drop from the ocean of our expenditure would sufficiently im-pregnate the powers of taste, in a country naturally prolific in every department of genius[2].'

And the voices of Henry Wood and Henry Irving had, among many others, argued that the Victorian State could with ease and with ultimate profit support the performing arts.

Nevertheless it was, perversely enough, at Britain's darkest time that the Arts Council was formed. At the conclusion of the war Britain was losing an astonishing £14 millions a day. We owed the United States more than £10,000 millions. Our industry was in ruins, our bombed cities derelict. The British people were poorly paid[3], ill-fed, badly housed, tired and overworked. It was at that time that Lord Keynes and his collaborators persuaded Government to take the decisive step and commit themselves to the support of the arts in this country.

It was a high-minded, highly selective notion of the arts that the Government chose to support. The larger organisation that had provided entertainment through the popular arts of dance bands, singing and variety throughout the war, E.N.S.A.[4], was abruptly disbanded. It was the traditions of C.E.M.A. that became overnight the practices of the new Arts Council. The offices and officers were the same, and the use of panels, and regional officers were the same. And the view of the arts which C.E.M.A. had became the view of the Arts Council.

On the 12th. June 1945, in reply to a question put by Henry Brooke M.P., the Chancellor Sir John Anderson announced in the House that an Arts Council was to be formed from the wartime organisation. Later the same day Lord Keynes at a press conference gave the names of the people who (it had been decided in the sandbagged corridors of war) should serve on the first Council, and on the Scottish and Welsh Committees. Their names are given in Table 1. Their nucleus was undoubtedly an extremely powerful group of culture barons.

It has now become so much a part of our national picture that the Arts Council exists primarily to support the 'high' arts, and solely to support professional work, that it is useful to remind ourselves that in the early months C.E.M.A. had seen itself as largely supporting amateur work. Its first stated mandate was:

(1) To provide opportunities for hearing good music and for the enjoyment of the arts generally among people who, on account of wartime conditions, are cut off from these things.

(2) To encourage music-making and play-acting among the people themselves.

A great deal of the first work of C.E.M.A. was concerned with furthering the second objective; it cooperated closely with many amateur and community organisations.

The decisive steps away from that practice had in 1945 already been taken by C.E.M.A. but it is worth tracing the development of what was for many years to be the central thinking of the Council, not only because it bears on much that follows in this book, but because it dem-

Table 1

COMPOSITION OF THE FIRST ARTS COUNCIL

As announced in July 1945

COUNCIL

Lord Keynes (Chairman)	Mr. John Maud
Ivor Brown	Dr. R. Vaughan Willams
Lord Esher	Sir Kenneth Clark
Sir Stanley Marchant	Lord Harlech
Dr. B. Ifor Evans	Dr. O. H. Mavor

SCOTTISH COMMITTEE

Dr. O. H. Mavor (Chairman)	Sir George Pirie
Dr. Ernest Bullock	Sir William McKechnie
Dr. J. R. Peddie	Mr. Neil Shaw
Dr. J. T. Honeyman	

WELSH COMMITTEE

Lord Harlech (Chairman)	Mrs. Herbert Jones
Mr. Haydn Davies	Mrs. Parry Willams
Mr. Wyn Griffith	Sir Cyril Fox
Principal Ifor L. Evans	Mr. Thomas Taig

ARTS PANEL

Sir Kenneth Clark (Chairman)	8 members

MUSIC PANEL

Sir Stanley Marchant (Chairman)	15 members

DRAMA PANEL

Dr. B. Ifor Evans (Chairman)	13 members

onstrates how far the Council went in emphasising the significance of centres of professional excellence.

The process is charted with revealing accuracy in a review published by the Council, *The First Ten Years 1946-56*, which describes the beginnings of policy clearly:

'C.E.M.A. was, to begin with, a patron of help-yourself activities in music and drama, a sponsor of amateur exercises in play-acting and music-making; but soon it began to enlarge its sphere and influence in a variety of ways. Instead of being simply a grant-aiding body assisting amateur societies it began direct provision on its own account.' (p. 7)

That direct provision led it, at the conclusion of the war, to make a clear distinction between amateur and professional work, although the role assigned to the amateur seems a peculiar one:

'Both are supremely important, but for different reasons. The amateur practice of music or play-production or painting confers a variety of benefits upon its participants. Without seeking to arrange these in any order or proportion one may say they include, for instance, the theraputic and social consequences of choral singing or oil-painting; the development of appreciation; the provision, especially in smaller communities, of concerts and plays that would be economically beyond their reach on a professional basis. On such grounds as these the amateur performance of the arts is a vital and significant element in the national provision. But very rarely is it possible for the amateur to attain professional proficiency; not through any lack of talent, but through lack of time. The achievement and preservation of standards in the arts is, primarily, then, the role of the professional, just as the task of diffusing the arts outside the cities is largely the business of the amateur.' (p. 11)

This reeks of the Victorian sermon, a mite sententious, attributing virtues rather uneasily to states the writer plainly considers those of deprivation, and ending lamely with the view that professional art (with 'standards') is for the city dweller, but elsewhere Britishers must rub along with the amateurs who haven't the time to achieve excellence. Such rhetoric however is often used, as here, to disguise the key notion, which is that 'standards' are now held to exist *only within the province of the professional artist.*

This is a key logical jump in much Arts Council thinking. Whereas many reasonable people would think it made perfect sense to talk about standards within the realms of arts education, standards of critical appreciation by audiences, or standards of personal achievement in amateur and community work, this strain of thinking must exclude the use of the word in all these areas. For it is necessary that the concept of 'standards' must be given a new definition; 'standards' must be absolute, achievable only by professionals doing certain things, and must be the distinguishing measure of an entity which radiates values to other work:

'The Arts Council believes, then, that the first claim upon its attention and assistance is that of maintaining in London and the larger cities effective power houses of opera, music and drama; for unless these quality institutions can be maintained the arts are bound to decline into mediocrity.' (p. 22)

By this kind of thinking, the 'standards' of the professional 'power houses' (sic) do not simply set a mark at which amateurs, community artists, teachers and audiences can - whatever their differing interests - aim if they choose, but that mark is now both a sign of professional achievement *and* a sign of the achievement of everyone else. A nation's artistic life is to be judged solely by the quality of its leading theatre, orchestras and opera house. It is apparently not possible for other forms of creation and understanding to be above mediocrity when the power houses dim a little.

Plainly this cannot be true at least for the creators of art. Writers, Composers, Artists have merged more often from folk and amateur traditions than from professional ones. Notoriously, original work in these realms commissioned by the great power houses has been unsatisfactory - how much great writing or great composing in the last thirty years has come from establishment initiatives? The sense in which the notion is better understood however is in the way it refers to the performers of art; the sustaining of grand opera, high quality orchestral playing, large-scale classical theatre seems to need the resources of space, technical equipment, time and highly trained people that only an effective power house can attract and maintain.

For some this is to evade a central moral question. If large and expensive ensemble companies have acted as transmitters of the high arts in the past, must they necessarily continue to do so? Is it inevitable that our highest experiences in music theatre must come from grand opera - an entertainment which was uneasily grafted on to the cultured Londoner's taste in the eighteenth century - and must our mediocrity or otherwise be judged solely by its health? After all many of the most tyranical and bloodthirsty regimes of the twentieth century have been noble patrons of the great Opera Houses of the State.

To which there are only two kinds of response. One is to say what many of the writers in this book will say, that provision for excellence is invariably an uncertain and dangerous affair, and that at least in its early years the Arts Council had a general code of practice. Without it, all would have been chaotic. How else, if there had not been some general notion such as this, could the Council in its early years have responded, or how could it have decided (as it did in most areas of the arts) to act itself as a promoter? The second response is that of the hostile observer. He will say that the Arts Council was in effect a tight coterie of cultivated establishment figures, ignorant of and even hostile to many of the traditional arts, crafts and pastimes of the British, a

group inevitably more concerned with their own pleasures and those which seemed to be an emblem of national prestige than with genuine communication between artists and the generality of the post-war population and that they knew no other way of judging the arts. On this view the famous post-war rallying cry 'The best for the most' is either to beg the questions, of what can qualify to be judged as the best and who properly is a part of the most, or it is wilful perversion of language, a sham populist slogan used to aggrandise a minority activity.

In the early years the Council *was* inevitably concerned with minorities. It was an extremely small organisation, and some measure of how little contact it could have with the mass provision for leisure can be taken from figures. In 1945 the grant for the completed financial year was £175,000, which rose to £235,000 in the Council's first full year of operation. (See Table 2). Meanwhile in the same year the impoverished British, in search of leisure activities, spent £97,000,000 on dog racing and football pools, £50,000,000 on attending the cinema and £7,000,000 on fizzy drinks. It was in truth 'a drop from the ocean of our expenditure.' Thus to use the phrase 'The best for the most' could not conceivably be to use it as it might have been used in the other new State industries. In the obvious sense, it was unrealisable as an aim for the new Council; with such resources it was not possible to bring most people into contact with the best things, however eclectic the definition of the arts.

It would have been a more realistic and realisable aim for the other arms of the Welfare State - the Health Service or the newly reconstructed Education System - but for the Arts Council it was plainly a rule of thumb, to be used only in those small areas in which the Council could have influence. In later years, as the Council's annual grant from Government grew and with it its prestige and power, so did the Council come to think more deeply about the nature of 'the best' and of 'the most'. After twenty-five years it was not possible to be so sure and so simplistic; different strands of policy interwove in the enlarged organisation and there were plainly quite different emphases in the different art forms. Now, after thirty-five years in operation the Council is obviously speaking with many voices. Different philosophies of 'the best - those of the community arts movement and the preordained excellences of the apostles of high art are two such - are competing for resources, and although at times the Council may choose to pretend that there is one unifying philosophy, it has plainly become, with increased size, a sophisticated means of accommodating conflict *about* cultural policies rather than an instrument of any one clear policy.

14

Table 2

Annual Grant-in-aid to the Arts Council 1945-1979

Up to March 31st			Up to March 31st		
..	1945	175,000	..	1963	2,190,000
..	1946	235,000	..	1964	2,730,000
..	1947	350,000	..	1965	3,205,000
..	1948	428,000	..	1966	3,910,000
..	1949	575,000	..	1967	5,700,000
..	1950	600,000	..	1968	7,200,000
..	1951	675,000	..	1969	7,750,000
..	1952	875,000*	..	1970	8,200,000
..	1953	675,000	..	1971	9,300,000
..	1954	785,000	..	1972	11,900,000
..	1955	785,000	..	1973	13,725,000
..	1956	820,000	..	1974	17,138,000
..	1957	885,000	..	1975	21,335,000
..	1958	985,000	..	1976	28,850,000
..	1959	1,110,000	..	1977	37,150,000
..	1960	1,218,000	..	1978	41,725,000
..	1961	1,500,000	..	1979	51,800,000
..	1962	1,745,000			

* inflated by the inclusion of a final payment to the Council for the Festival of Britain.

Indeed it is noticeable that the highly experienced writers in this book use any blanket phrases or simple philosophic statements with great caution; the story that emerges is of cautious experiment, of political compromise, of guarded public statement. That is entirely understandable. The Council inevitably takes a series of small, informed (often pragmatic) judgements about the allocation of its resources, but to describe the nature of these decisions in any other than the most bland of terms is difficult. When a panel decides to aid a group or an artist they are taking a decision in which economics, assessment of public taste, critical judgement and political expediency all play a part - to convey with any truth the nature of each of these decisions would be to ask the Council to spend more time in public explanation than it does in making its judgements and in carrying out its decisions. Therefore the tradition has grown that the Council speaks through slogans more poetic than political.

It is however the reason for this book. The actual spending of the Council is recorded in great detail in the Annual Reports which cover fully the work of thirty-four years. The writers in this book seek to take in each case something of the longer and more general view. Although -

inevitably - what is discussed is highly selective and much is omitted, what emerges is a picture of the ways in which a strange, unique national institution has chosen to operate, the language it has chosen to use and something of its achievements.

Inevitably too some readers will find it too narrow and even too smug. The Council is of course much more than a simple funding body, it is a symbol - for some, a symbol of dangerous anarchy, for others, of ingrained establishment attitudes. For such people no account of the Arts Council can be complete without its dangerous revelations, its stories of intrigue and its swingeing exposé of the institution and all its ways[5]. Interestingly indeed, many people in the arts are more interested in arts politics than the arts themselves, an evasion of commitment to the real political world that future historians may find revealing. Of course such exposés can be made - there *are* deals, panels are sometimes hoodwinked, figures not presented in the clearest way to enquirers, dubious and undemocratic decision taken - but on the whole it is hard not to take the view that the Arts Council has by and large been at the least a remarkably interesting experiment in cultural democracy, has achieved some noble ends, and has used the nation's resources with greater care and sometimes to greater effect than any comparable institution in Britain.

There is much that it has not achieved. It has not aided, indeed on some accounts has positively harmed, many of the popular arts. It has been too little concerned to look at the interaction of the pervasive media with the live arts and (until recently) has been curiously distant from the State Education System. For two decades and more an observer could with some truth accuse the Council of being too little concerned with the regions, and too little concerned to think about devolving its interests in the capital and in the power houses of the high arts - although a fair-minded observer would acknowledge that there has in recent years been a decided shift from that position.

Worst of all, it has undoubtedly done something to stifle the language of the arts. Its slogans may have been rules of thumb, but they were often taken for edicts, and what are we to think of a use of English which means the word 'standards' cannot be applied to amateur work, or that 'the best' is not a term more applicable to some circus acts rather than to others? By appropriating language, the Council has made dialogue over cultural policy more difficult. It speaks of 'responding to need' without any attempt at definition of that remarkably elusive and slippery word 'need'. It affects to be governed by an 'arms' length principle' that is of course not a principle at all but a shadowy series of

practices and newly acquired habits that do not bear examination in the way that a legal or moral principle will normally bear it[7]. It lays itself open always, by its use of the phrase 'the most', to attack on the grounds that it plainly is not centrally concerned with what most people do most of the time; watching television, gambling, gardening, cooking, sport, listening to pop music, remain for 'the most' of greater interest and of greater reward than opera, classical theatre, contemporary art and serious poetry.

Yet in the years of the Council's growth the audience has undoubtedly grown for all kinds of art - the audience for opera has grown as rapidly as the audience for popular singing, the audience for legitimate theatre as rapidly as that for illegitimate entertainment. It may be argued that this has been not so much as a result of any long term Council activity, but simply a by-product of the universal availability of higher education and the overall increase in wealth. All that the Council has done, according to that view, is cater for the middle classes as they enlarge. Certainly surveys bear out such a picture; the composition of audiences today - for all our seat subsidies and for all the fact that the audiences are much larger - is of much the same social mix as before the war. The subsidies on the seats are another bonus for those who have already been subsidised by the State throughout their long educations.

This is not a condemnation of the Council's work. An enlarging educated middle class is an inevitable result of our rather social policies, and although they bear that limp title many of the middle class are first generation visitors to the arts. At least the Council's intervention is of a kind that brings some results and they are meeting one level of demand, even though it plainly does not achieve the more grandiose ambitions of the Council or some of its critics. Rather it is a criticism of our overall social policies, for the Arts Council's intervention on behalf of the new middle class is still virtually the only significant intervention by the State. If such intervention is in any degree enlightened, why is it concentrated so much upon one part of the arts and perforce upon one part of the social spectrum? The diversions of other classes and groups are in the hands still of commercial operators, or of political and religious agencies.

Effectively, the Arts Council is of course too small to be concerned with the full spectrum of 'the best' and certainly too small to be concerned, in the ordinary sense of the word, with 'the most'. It cannot be blamed for that. It can however be blamed for (at times) a deliberate parochialism, a desire to stay small, a feeling that in minority activities lie the higher virtues and of course 'standards'. It is a typical enough

British reaction. The spread of printing was reckoned to cheapen and vulgarise the calling of a writer by enlarging the profession and enlarging the audience at a stroke. Opponents of radio saw in its spread the same danger, and such fears have been expressed about television (the supreme disseminator of good drama, as radio is the supreme disseminator of good music) since its early days. There is always something dangerous to the practitioners of the high arts about their spread, a feeling that the replication of an art destroys its best quality, its uniqueness and its ownership by a properly educated class. Mixed with its reasonable political caution, there is always a wary feel about the Council's protestations that it wishes to have greater funds to achieve greater ends:

'Two and a half million a year would adequately finance not only the range of enterprises which the Arts Council and the Local Authorities assist - and which, because of wage increases, will cost much more next year than this - but would also provide the money for the long-term rehousing of the arts. The current scale of collective patronage is by no means discouraging regarded as the achievement of a single decade. But it should be multiplied by at least 2½ if, in the next ten years, something substantial and permanent is to be built on the basis of the last ten years.'

Of course it was apparent, in the year of Suez when that was written[6], that two and a half million pounds a year would be wretchedly inadequate to rebuild theatres, build concert halls, galleries and fund artists. I read those words, as it happens, in Leeds - a vast city in which it was not possible to see contemporary art, see any but the most occasional contemporary drama in a pre-London 'try out' and difficult to hear music composed later than Elgar. It seemed then, as it seems now, too gentlemanly, too discreet and too complacent.

Now, more than twenty years later, talk as we may (rightly) of the Arts Council's successes, we must concede they exist within a narrow confine. The combined funding of Local Authorities and Arts Council can scarcely keep live theatre in cities such as Chester and Coventry. A city the size of Nottingham still does not have a decent Concert Hall. It is still difficult to see contemporary art if you live in Leeds. We still have not been able to aid the arts in any serious sense for ethnic groups, for children or for country dwellers. In spite of its achievements, even its friends may consider that the Arts Council has grown too used to lowering its voice respectfully for the benefit of authority and that it could with profit yell and shout a little more.

To turn however at the last to the brightest sign of all, an increasing

number of people care enough to argue about the Arts Council, to debate its function and role with fervour and to urge it to new endeavours. Every achievement claimed for it in this book will be disputed; every statement of philosophy questioned. For all its liking for the back corridors of persuasion, the Council is seen as moving more within the corridors of power. And more people care more seriously than ever before about the vital relationship between the artist, the audience and arts administrators: as the Council stands (quite often) exactly where the three meet it cannot avoid our scrutiny, our criticism or our thanks.

NOTES

1 Referred to as C.E.M.A. throughout the book.
2 Martin Archer Shee, **Rhymes on Art.** (William Miller, 1805).
3 The average wage had risen to £6. A theatre ticket cost (in today's money) 15p, a paperback book 10p, admission to the cinema was 5p, a pint of beer 5p, 20 cigarettes 12p and petrol 11p a gallon.
4 Entertainments National Services Association. Not referred to again in the book.
5 A list of some more hostile analyses of the Council's role and functions is given as an appendix in this book.
6 **The First Ten Years** (Arts Council, 1956) p.30.
7 The 'arm's length principle' probably has its roots in the first world war. The War Office Cinematograph Committee, which gave Government grants to British film producers, accepted that control of content lay with the producers themselves and with the British Board of Film Censors, a body run by the industry, and which had been formed in 1913. Prior to that in its aid of the national galleries Government control had been far more direct.

HOW THE ARTS ARE PROMOTED

Hugh Willatt

"Since 1939 much has changed in the way the arts have reached the public". This was the opening sentence of a short book called *The Arts in England* published in 1949. Its authors were Professor Ifor Evans and Miss Mary Glasgow, respectively Vice-Chairman and Secretary-General of the recently Royal Chartered Arts Council of Great Britain, successor body to the wartime C.E.M.A.

It is interesting to note where the emphasis is placed; not on the recent and, as it seemed at the time, miraculous, availability of public money, but on the emerging pattern of promotion. "A new shape is becoming visible in the organisation of music and the visual arts and drama and in their distribution throughout the country. The difference is apparent in the change of the nature of patronage, in the size and constitution of the audience in the post-war world, and in the types of organisation which the artists have found necessary in order to present their works to the public."

These are big words, and they proved, in the event, more than justified. All the same, it was a modest book. The writers, excited by the success of a limited wartime expedient, do their best to preserve a quiet tone, as if fearful that excessive claims might alarm the powers that be; the politicians, and the taxpayer, not to mention that section of the business world which was itself engaged in the promotion of the arts and entertainment. The tap could be turned off and the supply dry up, despite the permanence and independence apparently secured by the new Charter.

The modest financial assumptions make surprising reading today. Certainly there is no hint that within thirty years Arts Council funds would grow from £575,000 to more than £60 million; or, to put it another way, that money increased in this measure would so soon be needed to support the success of activities grown so dramatically in number and in scale. Nor is there any beating of the drum over the pathetic inadequacy of the government provision. It was only later that the Council, under the leadership of the redoubtable W.E. Williams, became confident

enough in its independence and its future to proclaim loudly and publicly the needs of its clients and therefore of itself. In those days, and for many years, there was no Minister with Responsibility for the Arts, and the Treasury, which made the grants direct, doubted the propriety of this sort of behaviour by the Chief Officer of a new little agency of government. Soft pedalling of the money implications may have been good tactics in 1949 but, this apart, to prophesy the way things were likely to go, even to plan, cannot have been easy.

Was it the Council's function itself to promote activities or to give grants to others wanting to do so? C.E.M.A. had, after all, won its initial success and popularity as an organiser of performances and tours, of concerts, theatre and art exhibitions, in conditions of blackout and dispersal. Were standards of excellence the prime objective, or the spread of availability to more and more people even at a lower standard? How could a tiny sum of money most usefully be spent?

Williams, when he took over as Secretary-General, became a great coiner of slogans. 'Art for the People' already had a thirties and wartime echo, but those which followed in the early Council years 'Raise or Spread', 'Prime the Pump', and even 'Few but Roses' were mainly kite flying, to create discussion or to help clarify policy. They show how tentative was the Council's attitude, at any rate in planning terms. There were no blueprints, no schemes for Regional Centres strategically placed, none of the sweeping vision of a Malraux, or speeches linking our artistic genius with our national destiny. Considering the amount that government in fact provided, grandiose schemes described in grandiose language might anyway have sounded rather silly.

There was, on the other hand, quick reaction to things that were actually happening, and within the limits of the given resources, response with encouragement, when quality and need fell together. There was also the doing of things which needed to be done and which no-one else was doing: organising exhibitions, small scale opera touring, grants to individual artists, purchase of works of art, training schemes.

This is no policy statement: only a summary of practices found to be effective. But at any time in the last quarter of a century a Council member or officer, pressed to define policy, would probably have offered something on these lines. In my own period as Secretary-General visitors from the United States would frequently say: "Tell me about your current projects". "We have no current projects" seemed a feeble reply, though one could always point to results.

Hundreds, eventually thousands, of activities sprang up all over the country, and their promoters certainly had projects, and marvellous

22

"Adventures in Art" at Midlands Arts Centre, Birmingham, one of the '. . . hundreds, eventually thousands, of activities . . .' that sprang up all over the country.

ambitious programmes. But for the Arts Council these words sounded suspiciously like planning and control. We were a government agency, given complete freedom to distribute public funds without government direction. We were finding ways of doing so, which in turn allowed the maximum freedom to the recipients, and which also evoked a multitude of initiatives which were not our initiatives.

There was nothing negative or passive about all this, as the Council staff of the period would testify. But in later years when Ministers for the Arts were appointed, one at least of them chafed at this lack, as he saw it, of a more positive role. A Minister who, by convention, must not himself make policy, in this, the largest area of his responsibility, will often feel frustrated.

The giving of subsidy was anyway not the only obligation. The Council was there to advise local authorities, and this usually meant persuading them to give money: to advise central government of the needs for the arts, and this meant very much the same. The Council had to become something of a spokesman for the arts as a whole, and particularly for the new ways of organising the arts. In these activities the pioneers, and

Williams in particular, showed great energy and skill. In the early years the Council stood not only for new methods of organisation, but for experiment in the arts and departures from tradition.

A policy based on response (or mainly so, for there was nothing absolute or rigid about it) meant response accompanied by encouragement and specialist advice, and the quality of the advice improved with rapidly increasing experience. It required knowledge of what was happening in the different worlds of the arts, personal contacts and perception. It was only possible because artists themselves, often of great distinction, and others involved in the promotion of the arts, freely gave their services on the Council's advisory panels. They knew instinctively that it was from their colleagues that the initiatives should come, and they found it no problem to accept that their own role, and that of the Council itself, was a secondary one - assessment, and advice on the giving of money. They helped the Council and its officers from the first to see things from the point of view of those actually involved, and made no attempt, as some of their successors these days tend to do, to steer Council help in specific directions, or to see themselves as representatives of particular interests.

Results were what mattered, and results certainly came: eventually no less than a transformation in the way the performing arts are organised in this country, and a very marked effect on the ways in which the other arts reach the public. Judged by whatever test - spread of availability, increase in attendances, the creation of important companies, a generally high standard with some peaks of achievement, world acclaim - this country's achievement since the war in the arts, at any rate, is quite considerable. Where lay the dynamic force which brought about the changes which made these achievements possible?

A small amount of public money, less than a million pounds in each of the first thirteen years, intelligently distributed, seems in itself hardly enough to explain what occurred. So far I have talked mainly about the Arts Council. But the story of that Council is far from the whole story. Other energies were available, waiting to be tapped, and I shall emphasize two of them. One was eagerness of lay people, not professionally involved in the arts, to join together to organise new ways of artistic promotion. The other was the welcome given to these initiatives by the professionals, who found that the new structures, provided with lay help, fitted their needs. This was hardly surprising, because for fifty years or more, many of them had been trying, with inadequate resources, unless the occasional millionaire turned up, to create organisations on the same lines, sometimes short-lived, but often amazingly product-

ive. There was, in other words, before the Arts Council existed, an alternative system ready to take over. The Council and its money provided the catalyst.

But before these elements are considered one preliminary question has to be asked. How much would have happened anyway had there been no public money and no Arts Council? Changes there would have been, and radical ones, simply because society itself changed so radically in those years after 1945. The country, in its post-war mood, was ready for new ways of doing things in these matters, as in others. The spread of opportunity for education in the twenties and thirties, Penguin Books, gramophone records, art publications and, above all, B.B.C. programmes, had prepared the ground, and during the war itself and in the early years after it ended, there was something of a thirst for the arts and for art presented in the new ways. Secondly, commercial promotion of the performing arts in live form became less of a viable proposition as time went on. The size of theatres and concert halls imposes inescapable limits on the box office takings, while costs go on rising beyond a level to be met by increase of seat prices. Television arrived with a shattering effect on the entertainment industry as a whole, and theatre, ballet and concert promotion had been a part of that industry. The entrepreneurs and the showmen switched their activities and their flair to the mechanical media - to recordings, television and video, as well as radio and film - and live entertainment became something of a sideline. These changes and developments do not in themselves account for what happened - far from it - but they certainly left the field more open. Any suggestion, nevertheless, that competition from the subsidised sector hastened the commercial decline hardly bears examination, if it is based on the amount of public subsidy. It was thirteen years before the Arts Council money reached a million pounds, and of that more than one-third went to Covent Garden. Commercial decline had by then begun. On the other hand, the effort, skill and enthusiasm which created the new subsidised enterprises were of the sort which moves mountains.

The money talked all the same: small though the amount was, the simple fact that it was there had a great effect, both morally and in practical terms. It sparked the energies of people all over the country who, in the atmosphere of those post-war years, wanted to get something done. Ways of doing things, attempted over the preceding years, sometimes with splendid results, which had so often in the end had to be abandoned for lack of resources, now began to seem possible. A great deal could, it seemed, be done with very small grants. A few thousand

pounds could be enough to start a new project, a theatre, an orchestra, a gallery and arts centre or festival, a few hundred pounds for an existing enterprise to reach solvency and keep going for another year.

Those involved in the arts today can hardly picture a time still so recent when the State made no provision whatsoever, except in certain limited areas, such as museums and galleries. They think a wrong has been done if a grant is refused or inadequate. But in those early Arts Council years their counterparts, many of whom had before the war tried hard to keep some enterprise going on a few thousand pounds of borrowed capital, or, as performers, worked for a pittance because of the satisfaction offered by the job, greeted this new form of help with surprise as well as glee. It was never enough to remove financial worries, but it kept alive much that otherwise might have died. It also made it possible to start something new.

It was not all that difficult to obtain a grant of some sort. Indeed I would go further and say that for an organisation (as opposed to an individual) this has always been so. Of course, certain basic criteria have had to be met - as to 'need', as to 'quality' and as to 'viability' - three words begging scores of questions. But the record is there of the number and variety of the activities which have been supported, running eventually into thousands.

If it has been comparatively easy for an organisation to obtain a grant, it has always been difficult to obtain an adequate one. It is sometimes said that the Arts Council has retained its ability to respond to new applicants by keeping its existing clients half-starved. All the same, the Council's officers have acquired skill in assessing budgets, and it has over the years been something of a triumph to keep solvent a mounting number of enterprises with the help of a minimum grant, while retaining little or no reserve to help them in difficulty. There has over the years, been a minimal number of insolvencies.

A policy based on response can only work if the money available increases year by year. This has happened, though at first very slowly, and never in sufficient measure to secure standards or to allay perpetual concern, in Council and recipient alike. That governments have each year themselves responded to the growing need, however insufficiently, is evidence of change in public attitudes. And that change has, in return, resulted from the success of the supported enterprises and their strengthening position in the life of their communities. But though Arts Council money talked, and though that money grew as activities multiplied and demands mounted, there was no overnight transformation. By the end of ten years the grant-in-aid had only crept up to £820,000, and

most of what the Council supported and promoted still stood only on the edge of the arts and entertainment worlds. The government, it is true, looked to the Council to keep Covent Garden going (this obligation was supposed to be reflected in the size of grant-in-aid) and the Council itself chose regularly to put on exhibitions of international importance at the Tate - one of its most important early achievements. Here in these two major responsibilities successfully assumed, was evidence that things were going to work on the big scale as well as the small. But as for the rest, it was still mostly a fringe affair, viewed by many in the various art establishments as at best irrelevant, and at worst a lurking threat. In the battle against those establishments the Arts Council was regarded as an ally. Twenty years later, in possession of the field, the Council and its clients have had to adjust to a new view of themselves.

How did the move from the fringe to the centre come about? A clue lies, as I have suggested, in what Miss Glasgow and Professor Evans referred to as 'the types of organisation artists have found necessary in order to present their works to the public'. How are the arts in this country today, for want of a better word, 'promoted'?

Different societies have, throughout European history, devised many different ways in which to find a place for the artist, ask for his work and supply him with resources and a living. The Greek City State, the Mediaeval church, the Renaissance Pope and potentate, the eighteenth century prince, the impresarios, dealers and publishers of the nineteenth century; each in turn made provision for the creation of music and theatres, opera and dance, painting, sculpture and literature. In this country today these functions - call them 'promotion' or call them 'patronage', they amount, perhaps, to a mixture of the two - are fulfilled by thousands of separate and independent committees whose legal shape is that of a board of a charitable company. *Promotion by a committee in this sense, with financial assistance from state and municipality, is our present basic system for promotion of the arts.*

Why have these boards, made up of solicitors, teachers and business men, some of them with a strong amateur interest in the arts, a sprinkling of local councillors, and often a vice-chancellor as chairman, been so effective, both in building up a new enterprise and in keeping it going year after year? Their responsibility is neither nominal nor merely decorative. The director of any limited company has unavoidable obligations, and in this case the boards are recipients of public funds and accountable for their expenditure. They also make the key appointments (and when they judge the time to have come, the re-appointments) for the running of the enterprise. They often deal with an annual

turnover of millions of pounds. Why has it worked?

The charitable element in the company structure gives a first pointer. This brought some immediate advantages by way of relief from rates and taxes. The cost of the activities need include no provision for interest on borrowed capital or return on an investor's money. Buildings were provided, highly specialised and costly ones, without any burden of rent, loan redemption or interest charges. Working capital came, in effect, from the subsidy, and given this contribution, box office takings were able, just able, to cover the cost of the enterprise. The work of board members, sometimes of an executive nature, was not paid.

But the charitable structure signified more than cost-saving. The arts became a 'good cause.' This country had no tradition of state support for the performing arts. But there was another tradition which could be called in aid. When something needs to be done (or, for that matter, to be stopped) people get together in a committee to do something about it. The British middle classes organising themselves in this way can be a powerful force. In the years after the war, because of the atmosphere prevailing at that time and the stimulus given by availability of some public money, people of this sort were to be found in communities of every size, willing to help keep going or to create from nothing, an orchestra, a concert series, art exhibitions, festivals, arts centres - or a local theatre. They were not, be it noted, merely money-raisers.

The theatre was the test case. The idea that theatre could be a worthy cause was not entirely new. From the time Miss Horniman started her Manchester Repertory Theatre in 1908 the 'Repertory Movement' became such a cause. Given her money in support of an admirable policy, given the flair and expenditure of a Barry Jackson in Birmingham, another person of great wealth, or given a well-conducted enterprise such as the Liverpool Playhouse, the artistic results could be splendid. But generally the standard of the repertory theatres of the twenties and thirties, with their weekly change of programme, was not all that high. The idea, however, the proclaimed social purpose, the absence of show business quality, the very fact that these enterprises were 'struggling' made them acceptable to public-spirited people, even, or perhaps especially, those in whose minds there still floated certain Victorian ideas. Support for museums and galleries, whether by state or municipality, or by individual beneficence, had been justified on the grounds that they tended to elevate, to educate and to refine. Perhaps this justification could be extended - even to an art most obviously designed for immediate enjoyment - if its protagonists were ladies like Miss Horniman in Manchester, or Miss Baylis at the Old Vic, and actors could be dedicated young people in the mould of Sybil Thorndike and her husband.

Having once accepted the arts, including the theatre, as suitable objects for philanthropic effort, the 'do-gooders' were able to make a solid contribution. They provided useful links with a surrounding community, a familiarity with committee work, and ease in treading the corridors of power, national or local. Not surprisingly, the work had a fascination often lacking in pet charities of the usual sort, many of which anyway seemed less important with the coming of the welfare state.

But it often went much further than that. Without a very special contribution from within many of the local boards, the number of companies in their own theatres would not have grown in twenty years from fifteen to seventy, and the new theatre buildings would not have been built; our regional orchestras would not have been in their present positions of strength, and our fifteen major arts and music festivals in an incredible total number of 250. The London musical scene, the busiest in the world, would be less active and varied than it is, and we should not now have five major opera and five major dance companies. To all these achievements board members, often especially their chairmen, have made a vital contribution largely unsung. (Only in one case, that of the four London Orchestras, is there no lay board: their boards are elected by their own members.)

That is only one side of the picture. The people who came forward voluntarily to further a cause did not invent the idea of artistic promotion by independent groups working together on a long-term footing. In fact, the pattern of alternative provision had already been laid before the post-war reinforcements and the money arrived, as a result of pioneering efforts in the twenties and thirties by the professionals of theatre, opera, ballet and music.

In his book *The Other Theatre* Norman Marshall gives a most valuable account of provision on this alternative pattern in the years between the two wars, not only for drama but for ballet and opera. He begins by describing what he, as a theatre-struck young man just down from Oxford, was able to see in London in 1925: a range of plays, past and present, British and foreign, which compares very well with what is on offer in our commended and subsidised theatre of today. But there is one basic difference.

"The theatre which staged most of (these plays) was struggling for existence in strange out-of-the-way places such as a drill hall in Hampstead, re-christened 'The Everyman Theatre'; a forgotten playhouse in Hammersmith which had been a furniture store; a cramped little cinema out at Barnes where Komisarjevski was performing miracles of production on a tiny stage; and a back-street attic in Covent Garden in which the Gate Theatre had just started."

There were a dozen or so Sunday play-producing societies, a now forgotten phenomenon, organised by the profession or by their audience members, in which actors and producers, seeking a wider range of work, spent a great deal of their spare time in rehearsals for a production "hurried into Shaftesbury Avenue theatres on a Sunday night and hustled out again after sometimes being allowed to give a second performance on Monday afternoon".

The young Norman Marshall was able to enjoy these experiences because people working in the theatre had, from the early years of the century, wanted conditions which would make possible a drama more adventurous and more satisfying than the West End and touring systems allowed, and they set about creating them. We cannot explain this country's great achievement in theatre, music, opera and dance since the war without taking account of a rich variety of efforts in the pre-war years by some remarkable people. Ninette de Valois at Sadler's Wells had created the first great English ballet company; Marie Rambert, working on a smaller scale, had shown her special gift for the discovery and the nurturing of talent. There was the growth of the Sadler's Wells Opera Company, and there had been Sir Thomas Beecham's earlier struggles to create opera under permanent and stable conditions. The Glyndebourne seasons of the thirties were an outstanding example of what could be done by a group of individuals with an exceptional leader who knew what they wanted to do and could rely on a measure of private munificence.

In the theatre there had been the Granville Barker period at the Court, which though it only lasted three years was as creative in its way as the George Devine period in the same theatre fifty years later; the efforts of Miss Horniman at Manchester and Miss Baylis at the Old Vic and Sadler's Wells; the work of Nigel Playfair, J. B. Fagan, Terence Gray and Peter Godfrey in the twenties; of Marshall himself and Anmer Hall in the thirties; and throughout the whole period, of Barry Jackson in Birmingham, in London, and at his Malvern festivals. Jackson and Beecham and John Christie at Glyndebourne had wealth, and were able to provide from their own pockets resources on the sort of scale that an Arts Council was able eventually to supply. The rest managed to do what they had to do on small sums scraped together from a few well-wishers.

In acclaiming what has been achieved since the war we should not forget how much of it was built on foundations laid by people such as these. We should at the same time remember that however seminal in their effect, these activities were mostly on the fringe, often precarious and short-lived and always starved of resources. When the war ended, many of these pioneers were still there, and their work continued, strength-

ened by the new resources. They were joined by a new generation who seized the opportunities offered by subsidy. In some cases it was the professionals themselves who took the initiative and formed their own companies, inviting a group of laymen to make up the controlling board. The Mermaid Theatre, the creation of Bernard Miles, is one example. The English Stage Company at the Royal Court was formed by professional artists with help from a number of very able laymen. In London, particularly, a number of opera and dance companies came together in this way.

But the organisations brought into being by laymen, mainly in the regions, depended entirely on the flair and skill of the professionals they engaged, and the post-war generation of theatre directors, in particular, responded to the challenge and the opportunity. Our remarkable chain of regional theatres would not have been possible without the dedicated work of a talented group of artists, mostly young, who had to become impresarios as well as directors of plays. From them, and from the actors, designers and technicians who worked for them, have emerged the leaders and the livelier members of today's theatrical professional, contributors to commercial theatre, to television and to film. And because

The licensed bar at Theatr Clwyd, Mold, one of many in the 'remarkable chain of regional theatres . . .'
Photo: Newcombe & Johnson

31

these theatres existed, and were helped by Arts Council New Play grants, a fresh generation of playwrights emerged, particularly after the Royal Court had given the lead.

In many ways the pattern of the country's theatrical life came to resemble the pattern of its musical life. In music there was already a long-standing tradition of 'promotion by committees' and of community effort; not in this case an alternative system waiting to take over, but a part of the main stream. In the organisation of music, as compared with the theatre, there had never been that clear-cut division between the commercially-promoted on the one hand, and the voluntary effort on the other, or for that matter the same gap between amateur and professional work. Symphony orchestras were operated by amateur choral societies, music festivals by cathedrals and chapels, chamber concerts by select gatherings of a local elite. Teaching and performing were often closely linked, and music was a recognised part of the life of church and chapel and of our educational system. A former music critic of the *Times*, describing the earlier years of the century, wrote: "We may doubt whether it will ever be easy to form a picture of the musical life of the country, as the phrase goes, for that addition sum of the amateur, professional, educational and ecclesiastical effort which is recalcitrant to simple arithmetic". When the Arts Council arrived to add strength where it was needed, that picture became much clearer. On the one hand, concert promotion by a commercial impresario, unaided by subsidy direct or indirect, became less and less a practical proposition. On the other, promotion by groups and societies all over the country or by musical ensembles themselves, now receiving grants from local as well as national sources, resulted in a system strong enough to support a great flowering of our musical life, metropolitan and regional. The number of promoting groups grew each year, and concert-giving and concert audiences alike increased, in London, enormously so. Higher standards were attainable because of regular engagements, more rehearsal time, and the generally greater stability given by subsidy.

The pattern of the country's theatrical life (opera and ballet included) came to resemble the pattern of its musical life, while the latter strengthened and clarified.

In one case only, and that an important one, was an organisation planned at government level. Covent Garden, soon to be the Royal Opera House, was essentially a new creation, only possible under post-war arrangements. It was accepted by the founders of the Arts Council and the then government that this country should for the first time have an opera house in the full sense, with its own permanent company, orchestra and staff. A large slice of the Arts Council grant in the early years went for

this purpose. The result was all, and more, than those who made these policy decisions had hoped for, and Covent Garden became one of the world's great opera houses. Its other constituent company, the Royal Ballet, had quite soon a similar standing. But here again, though there is a Royal Charter, this organisation, with its thousand employees, is operated by a governing body, in effect self-appointing, on the same lines as all the rest, and the size of its grant is wholly determined by the Arts Council. Its board has the heavy responsibility of an operation with an annual turnover of £10m., and is now, more than most boards, involved in fund-raising efforts. Covent Garden's remarkable standards and box office success owe a great deal to the enthusiasm and ability of its chairmen and the activities of many of its board members.

It was twenty years before this precedent was followed and government (with the GLC) planned and supplied the resources for the building of a National Theatre, though in 1947 Parliament had passed an Act authorising this provision when the time was ripe. The significance surely of the National Theatre pre-history is that all the planning, the schemes and the propaganda over 70 years came to nothing until the theatre of this country had become reorganised and there was in existence a nationwide chain of theatres operated, though on a much smaller scale, on the lines conceived by Granville Barker, Bernard Shaw and the rest.

Much of what I have been trying to say is summed up in the history of the Old Vic and Sadler's Wells and their remarkable protagonist Lilian Baylis. All the elements are there: the beginnings in a charitable foundation linked with adult education, inspired by a Victorian sense of purpose in two spinster ladies and their helpers. The Old Vic is the forerunner of the National Theatre: for surely, despite its mixed ancestry, here is its true parent. But there was opera at the Vic before Miss Baylis installed a drama company; and Sadler's Wells Opera, after productive years at Islington and on tour, became English National Opera at the Coliseum. And it was also at the Old Vic that Ninette de Valois organised a group of dancers, forerunners of Sadler's Wells Ballet, which in course of time moved to Covent Garden and became the Royal Ballet. Those of us who remember the Vic and Wells' parents, and the cheese-paring which went on in their households, can only wonder at the splendour of their children who have got on so well in the world.

Again, one is led to ask what explosive force lay behind all this. Much was due to the personality of the lady herself. Miss Emma Cons's invitation to her niece in 1914 to take charge of the entertainment programme at the Old Vic was one of those events which are decisive for the future. Miss Baylis, as an English version of Diaghilev, is a strange

thought. The bossy English spinster who organised everything on the lines of a church hall, shared with the Russian genius at least one characteristic: she was the cause of brilliance in others. The Vic and the Wells, with their special followings, provided a structure within which artists of theatre, opera and ballet wanted to work; at first young artists, later the leaders of their professions. By the mid-thirties Miss Baylis had found herself in charge of two theatres already world famous, and in them at some time worked nearly every one of the actors, directors, opera singers, dancers and choreographers on whom this country's post-war achievement in these areas mainly depended. There they learnt their craft, and later contributed their mature talents. But the methods remained those of make-do-and-mend. There was no public subsidy available.

———————————— ✱ ————————————

My account of what happened is no doubt over-simplified, and I have dwelt too much perhaps on the arts involving performance - the theatre in particular. But of all the changes which came about, the re-organisation of the theatre was the most dramatic and significant: and as the performing arts generally need special buildings, numbers of skilled people and often lavish expenditure, before anything can happen, the question as to who will provide and organise these resources, and for what motive, becomes a crucial one.

To bring before the public the work of the painter or the writer is, in comparison, a cheap and simple matter. The market still provides a machinery, though the conditions under which the art dealer has to operate impose many distortions, and for the writer the book trade offers only a poor return for anything but a best-seller. There are wide gaps to be filled, and the Arts Council and the regional arts associations have done much to fill them; by help to individuals by commissions and purchases, by organising exhibitions and by giving grants to independent bodies doing the same. The gaps remain wide.

For the performing arts it meant, as we have seen, a more fundamental change, to a new system of promotion by people coming together within the structure of a charitable company. Each company has the responsibility for an artistic enterprise, operating on a permanent or long-term footing.

There was nothing new in this last concept. For opera and ballet the permanent 'ensemble' with a repertoire is the only way. And for theatre it has, in Europe, long been the norm for nearly all serious work. But until after the war we had in this country, in spite of seminal efforts on

34

the fringe, no great companies comparable with the Comédie Francaise, the Moscow Arts Theatre and a number of German companies. Orchestras, even, were unable to remain together on an all-the-year-round or contract basis.

I have said, or implied, that all these changes produced satisfactory artistic results; sometimes, for excellence will always be rare, remarkable ones. But categorical statements of this sort are really not enough, even if supported by tourist figures or favourable critical comment, both here and abroad. Some facts seem self-evident: a certain widening of repertoire and subject-matter, an artistic life less tepid and less provincial, the emergence in the period of some individual artists and a few ensembles of very obvious stature. Attendance figures suggest a frequent special quality to which an always increasing number of people have responded. But this, in some ways the most important question of all, demands further attention: some critical assessment of the whole period linking the artistic achievement with the system which helped to produce it. A book, not a short essay, is wanted. It may, all the same, be worth while to look a little more closely at the reasons for a flowering which did, I believe, in fact take place.

This happened, I suggest, because the system has allowed a little more freedom to the artist, more opportunity to be creative than he had under earlier arrangements. First, it supplied him with resources and it did so, as we have seen, cheaply. The supply has always been meagre. But it has, at any rate, been enough to allow creative people to work together in ways which they had shown in pre-war years they wished to adopt. And though never large, the money could be relied on, at any rate in a measure which offered that most precious gift, the opportunity to take risks, or at any rate to balance caution with an artistic gamble.

Secondly, the resources came in a helpful way. The board of an organisation was there to obtain the money, primarily from the Arts Council and other public bodies, but occasionally by fund-raising schemes for buildings and for other special purposes. The result, for those with the creative function, was a measure of release from acute commercial pres sure, including the need to produce a return on the investors' money.

Thirdly, the system proved adaptable to the needs of the large-scale operation as well as the small one. In the last twenty years of our thirty-year period there was not only a proliferation of artistic organisations, but a change in the scale of many of them. Covent Garden, the one giant of the early days, was joined by an enlarged Royal Shakespeare Company as a joint Stratford/London affair with eventually two additional studio theatres. The National Theatre with its three auditoria was opened

on the South Bank, and Sadler's Wells became English National Opera in that former temple of show business, the London Coliseum, with, in addition, an outpost in the north. Scottish Opera and Welsh National Opera became large-scale and highly important companies. In the Regions, enlarged theatre organisations acquired impressive new buildings in the centre of their cities. The mainly lay boards have so far proved capable of coping with enterprises of this magnitude.

That artists involved in the performing arts could call on these larger resources meant further opportunities and an addition to their freedom. And this happened at a time when the possibilities of wholly commercial provision on the larger scale were becoming steadily more limited. A play, for example, with a large cast or elaborate settings and costumes - meaning nearly all the classics and much modern work - would nowadays be economically impossible in Shaftesbury Avenue, unless perhaps it were an existing production transferred from a subsidised theatre. This is not to deny that productions of quality and importance continue to be put on by enterprising managements, but most, apart from musicals, have small casts. The contemporary playwright who needs to work on the larger scale, not to mention the composer or choreographer, can only look to a subsidised organisation for performance, and he now has the opportunity to do so.

It may seem ironical that at a time when artists have been given these opportunities, a number of them, young ones especially, have moved in the opposite direction. They prefer to work in unconventional buildings with small resources, partly in an attempt to reach new audiences, and partly because they do not want to be burdened with the paraphernalia of top-heavy organisations and expensive buildings, or to be tarred with an Establishment brush. Anyway, the smaller the resources needed, the easier it is to get something started. All the same, they require, and large numbers of them receive, subsidy. The system has been able, though with some strains, to accommodate this development: a sign, surely, that ossification has not set in. Not all these groups have received adequate grants, or grants at all, and some, whether grant-aided or not, are short-lived. But the number of them, and they cover opera, dance and performance art as well as theatre, widens the range of possibilities open to artists and performers. They provide the opportunity for experiment, often better on a smaller scale, and for this reason, as well as to accommodate a current trend, most of the new theatres have included studios for this type of work.

But for the promotion of the performing arts generally - and not only the performing arts - the charitable company still remains the prototype.

Something in the nature of these organisations has surely added a little to the freedom of the artist. They have all, even the largest of them, been on a human scale, operated on the spot, and not from a head office in the West End of London. They have provided continuity and stability and the stimulus which comes from people working together for a common purpose. They have often built up regular audiences, interested, critical and increasingly knowledgeable, and this too can be a valuable stimulus.

These, I suggest, are some of the reasons why there has been some extra spurt of creativity. There remains one crucial question. Who makes the artistic choices - on programme, on engagement of artists, on the composition of the working team? In the earlier days Arts Council officers used to worry as to where under the new system the 'impresario element' would be found. A committee or board cannot be an effective impresario. They need not have worried. The system has accommodated an Olivier, a Devine, a de Valois, a Webster, a Tooley and a Harewood, a Peter Hall and a Trevor Nunn, and to the best known names must be added scores more who directed enterprises, sometimes brilliantly, all over the country.

There have been occasional clashes between boards and their artistic directors, though rarely on the issue of choice of programme. What is remarkable is that there have been so few. A few years ago the artistic directors of the Royal Court Theatre had a lengthy discussion among themselves about the policy of their company. In the end, one of them said: "Policy is what you and I want to do". Implicit, of course, in the remark is the assumption that what any of them wanted to do would basically accord with the general outlook and purpose with which their company had been founded. This story is significant because what was said would probably be acceptable, not only to the board of the Royal Court, but to most boards throughout the country.

Certain limitations are inescapable. It may be significant that censorship of plays by the Lord Chamberlain was abolished during the period, and largely as a result of pressure from within the subsidised theatre. (The commercial managements were generally in favour of its retention.) Limitations arise from the very nature of performance. An enterprise, even if it receives subsidy, has to attract the public. Subsidy has never been sufficient to allow for many rows of empty seats, but the need to please to live can be a stimulus as well as a restraint.

Given this primary obligation to keep the enterprise alive - an obligation which is very much the concern of the governing body - the

relationship between board and the professionals has been well understood on both sides. It has been the easier because of a certain distance between them. A meeting of lay people in their spare time, every week or two, cannot mean close contact with the running of the enterprise, though the professional artistic director and the chief administrators will usually establish a close working link with the chairman of the board and one or two of its members, and those relationships have often been highly productive.

The board is the employer, certainly, but the word 'patron' might equally well describe a function which it shares with the Arts Council and the other providers of funds. Jointly they make up the machinery of provision, a giving with encouragement and without calling the tune. The word is traditionally suspect, and the relationship has usually been a guarded one - it still is - but throughout history the role of the patron in all its changing forms has been productive, and here is a form which seems to fit the society in which we now live.

It is all now taken for granted: the availability of public money, the promotion by autonomous and independent groups, and for artists, some greater freedom of choice. From within the world of the arts and from outside it there are now voices calling for change. This is as it should be, but some knowledge of what is still recent history could make for better debate.

So many critics and reformers concentrate their attention on the agencies of provision and forget the rest. This makes it easier for them, and is highly understandable if the critic is someone desperately striving to keep an organisation alive or to find an outlet for his own or others' talents. He will believe - often, though not always, rightly - that money would solve his problem. He will be reluctant to accept that the total supply is limited, and impatient with the argument that out of that supply, obligations to already supported activities must be met, particularly if those are activities with which he has no sympathy. He will invoke principals of fairness (that dubious concept where the arts are concerned) and suggest that a switch of resources from heavy spenders, such as the opera companies and the National Theatre, could be effected without any real destructive effect. In other words, he will attack the enemy-friend he knows, usually the Arts Council, though well aware that the basic problem is the smallness of the amount provided by Government.

These attitudes, which lie behind a good deal of current criticism of the Arts Council, are not only understandable, but valuable. A belief that you yourself are working on the right lines, and that others are on the wrong ones, perhaps as you see it, churning out something stale or irrelevent, has lain behind a good deal of artistic achievement in every era, and has certainly fired many of the achievements described earlier. But passionate conviction of this sort scarcely makes for calm judgment of those who give the grants. Nor does it qualify its holders or their representatives, as participators in final decision-making, if this should lead to fierce wrangles preceding an agreed carve-up, or colourless compromise based on mathematical formulae which satisfy no-one.

The Arts Council became successful because from its early years and onwards it was watchful and attentive to what was happening, and because its methods were pragmatic and often tentative. Should not these rules still apply? The motive force came, was encouraged to come, from below; from the people, lay and professional, who joined together to do things, and within those groups the power mainly lay with the artists themselves. Present critics and reformers are not only applicants for grants, understandably dissatisfied. They include journalists, politicians and academics who find it easy, because they think in these terms, to point to illogicalities and injustices, to supported activities they dislike, or to sections of the population which remain badly-served, and suggest that the remedy lies in reform of the Arts Council, or changes in the system of support at regional level. Reform of the subsidy system may be needed, but should it not still be in response to what is happening and what is changing in the world of the arts, the new movements, the emerging patterns of organisation and current needs, social as well as artistic? This response has, by and large, been forthcoming from the Council and the other dispensers of funds in recent years, but with increasing difficulty because of insufficient money and a much greater complexity in the range of activities calling for support, or in tasks needing to be performed.

It saves a lot of trouble to look at the matter this way round. Politicians particularly, and the civil servants behind them, seem often to have a touching faith, justified perhaps in other spheres, in a clever appointment to a chairmanship or a better-balanced committee. Friction between Government and the B.B.C., for example, has been known to lead to fresh appointments to the Board of Governors. Whether this has really produced the desired changes in the programmes, whose content and tone must mainly, subject to editorial control be dependent on those who make them, is surely open to doubt. But the B.B.C. manufactures

its own product. By and large, the Arts Council does not.

The important questions - the interesting ones - relate to what the artists and their lay helpers are now doing. Are they coming together in the ways they have done over thirty years? Can the independent charitable companies go on multiplying and developing, and is this a method which still suits the times? Is it the best way of securing a spread of availability to a wider range of the public? What is the future of the lay boards, and do they nowadays in the largest organisations on the one hand, or the very small ones on the other, fit the needs of the professionals? Are those needs best met by links between their organisations and the distributor of Government money in the capital, or by links with their regional or local body? How, given the need for accountability for public money, can provision be made for the casual and the transitory, for the individual artist and for the activity which fits into no recognised pattern?

Is it true that so far as the large scale organisations are concerned - the theatre, opera and ballet companies, the orchestras and the art exhibiting facilities - the job has been done? They are there and mainly well housed. (If this last is a fact, it represents a massive achievement, and it is worth recalling that Lord Keynes, when the Arts Council was first created, called attention to the lack of proper buildings and the need to "House the Arts" as a first priority.) Is the vitality which infuses these larger scale operations as great as ever it was - I believe that by and large it is - or has it moved elsewhere? Is what is happening and going to happen elsewhere a necessary counterpart and a supplement?

It is questions of this sort which need to be answered before new structures and methods are proposed for the machinery of provision, and the answers must come - are always in fact coming - from the people for whose benefit, and therefore for our benefit, the system exists. For the Arts Council and the other agencies, past history suggests the value of retaining the old flexibility and the traditional catalyst function. This means an adequate supply of money, and on that point more must be said later.

To suggest that what is needed is for those who sit monthly round the Arts Council table to be elected, and not appointed by the Government, might seem at best to be tinkering with the problem: at worst might it not lead to control from above? Representatives are there to reflect the views of those who appoint them, and to see that those views are translated into action. Would this arrangement not give to the Arts Council an authority it has up to now never claimed? It has the task - fairly humdrum - of studying budgets and regular returns and deciding what

is the minimum amount of subsidy needed to keep alive the enterprises already on its books: and secondly, given that first obligation (occasionally, though rarely, ignored), of responding to proposals for expansion in fresh directions, including the development of certain activities of its own. For these tasks it needs knowledge of what is going on and an independent judgment, and to be helped in both by advice from panels and specialist officers. Is it really true that, because of its composition, the Council has failed to respond, however tardily, to new activities, or to spread the net widely enough? Grants have usually been forthcoming simply because the applicant was there, clamant, in artistic terms palpably alive, and refusal was unthinkable. Somehow money has been found. I believe that the resulting spread in terms of variety and geography has been wider than it would have been if planned by a body representing various interests, artistic and social. This is conjecture, but it is surely doubtful whether a tighter system of subsidy provision worked out by representatives of artistic and political bodies would so well have fitted the needs of the ever changing mass of artistic activities. The constituencies from which representatives would be elected are simply not there, in any sense which would be generally recognised, and if they were specially created would this not mean the setting up of an Establishment of the Arts with its own bureaucracy?

The subsidised arts have not in this country hardened into establishment arts. This is a very important fact. The system accommodated, in its early days, a great deal of the avant-garde, and as time went on it found a place not only for opera, the National Theatre and the Royal Shakespeare Company (whose repertoires have anyway shown that they have never accepted a 'museum' role) but also for the Royal Court and the new wave, not only of playwrights, but of actors and directors of a wider range of social origin and outlook: not only for classical ballet, but for modern dance and its various exponents, and not only for concerts and performance on traditional lines, but for jazz and for the fringe.

Is there really anything wrong, even in democratic terms, in the Government of the day, responsible to Parliament, instead of handing over support for the arts to the civil servants, inviting a regularly changing group of people to perform this function? They in turn invite members of the artistic professions, also frequently changing, to advise them what they should do. All give their time without payment, and have the independence which this allows. The Council itself, though it has always included some distinguished artists, is made up of much the same sort of people as have come together to form the boards of the supported organisations, and those people, as we have seen, have had

their uses. Until recently it was widely held to be exactly the type of agency needed for subsidising the arts, admired and imitated in other countries. To say that it worked is not the usual cosy British justification for a theoretically indefensible institution. That it worked abundantly well is clear from the record of the last thirty years. Any proposals to alter the fundamentals of the system must start with this fact.

If the machinery is now beginning to creak, could this be because the Arts Council has taken on too many responsibilities in addition to the giving of subsidies, simply because something needed to be done, and nobody else was there to do it? Its knowledge, its contacts and experience mean that it is specially well-placed to do so many things. But there may be a growing incompatibility between the subsidising role, which needs independence and a certain distance from the activity, and the direct role, which means involvement and even occasionally competition. I would never suggest that the activities the Council have taken on are unimportant. Many of them date from my own period as Secretary-General.

The organising of touring, and the retention and refurbishing of a number of large regional theatres, so that touring visits of large-scale theatre productions, not only of opera and ballet, can continue in certain key cities; the operation of the Hayward and Serpentine Galleries; the opening of a book-shop; the making of art films; all these activities add up to a formidable total of administrative effort. To them must be added a widening range of supplementary services such as training schemes, grants for studio provision, for new work or the performance of new work in literature, music, drama or dance, for works of art for public buildings and for many more purposes. They are all intensely valuable, but should they be under the same umbrella, and does this not lead to confusion in the minds of applicants and of the public as to the Council's basic function? And in doing these things the Council seems to have accumulated a vast number of committees. Insofar as the motive has been a gesture to democracy rather than the need for advice, the results have not, I suspect, always been encouraging.

Words like 'democracy' and 'freedom' should be used with caution where the arts are concerned. But when they are, it is surely on the second that the emphasis should be placed. We may believe that our society should become more democratic, and the function of the arts in bringing this about. But the way to achieve these ends may not necessarily lie in the mechanical application of democratic principles for the appointment of those who will operate the machinery of provision. Freedom lies in the opportunity for artistic organisations to continue to

come together and to grow, giving artists the opportunities they need, and for these organisations and for individuals to be supplied with resources.

This means an adequate amount of money, and on this supply the whole system depends. If anything is to be learned from the experience quoted, the main source of supply must be from public funds. It must be regular, to allow those who receive it to plan and experiment, and it must be distributed with an awareness of the needs of all the recipients, existing and potential. The private giver, whether a company, a foundation or an individual, can pick and choose. The result can be productive if the choice is a good one. But business concerns, with their duty to their shareholders, have to look to advertising benefit. They are likely to prefer the larger and better-known enterprises. The ability of a company to give money varies from year to year, but the recipient needs certainty if he has to plan ahead.

What has come from non-official sources has been intensely valuable. Certain organisations, of which Covent Garden is an example, would, without this help, seldom be able to mount new productions. Business help to our leading orchestras is substantial. Fund-raising has been useful for special projects, particularly building schemes, though in these the Arts Council's Housing the Arts contribution has often been the decisive factor.

For basic revenue needs it can never be the answer. How can an artistic organisation plan and carry on its business if it has to rely for a substantial part of its revenue on the mounting of fund-raising appeals, an operation which cannot often be repeated: or on fortuitous contacts with the top management of a company whose purpose is wholly different?

People in charge of a business concern who would like to help the arts are not always interested only in the advertising aspect, or actuated solely by commercial motives, though they may have to convince the Inspector of Taxes that this is the case if the gift is to be allowed against tax. Advertising benefit can anyway be a quite proper motive and the result helpful to both parties. There may be a genuine sense of obligation to a community or a real wish to support the arts. But the giver will nearly always need to play for safety and be understandably reluctant to help something new or small in scale or likely to cause controversy.

It is surely true that the contributions made by boards of artistic companies to their enterprises has been the greater because their members have not been chosen for their wealth or their contact with wealth. Their social composition has been the wider for this reason and

their energies have not been too much diverted into fund-raising schemes.

The money provided from public sources must regularly increase, and not only in the amount required to cover inflation. To say this in the present climate may sound impossibly demanding, but it is something which has in fact happened under Governments of both colours in good times and in bad in each of the thirty years since the Arts Council was created. And it has been that extra amount which has been the key to the successful operation of the system. In a few of those years the increase allowed for little more than 'stand-still'. But even at those times the Arts Council preserved its flexibility, refused to accept that standstill is compatible with the encouragement of artistic creation, and somehow managed to provide enough to keep its already supported enterprises solvent, while retaining sufficient to allow a little extra for those of them with something special to give, and a first-time grant to something new, usually in some ill-served part of the country. The possibility of growth is not only an invigorating, but an essential ingredient in any artistic enterprise. The Arts Council has always recognised this fact.

If my summary of what has happened over thirty years is in any way accurate, it must be obvious that the whole system depends on a Government grant-in-aid which regularly and sufficiently increases every year. A reduction in the resources given to a hospital, a school or a university can be damaging. The service each provides will be reduced, but the result will not be insolvency. Cuts can be made. But the organisation receiving Arts Council grants are business enterprises, dependent on box office takings for more than half their revenue, and a reduction in the standards of performance may mean an even greater reduction in revenue from the box office. The size of the building and the unwillingness or the inability of the public to pay beyond a certain amount for their seats impose inescapable limits on the amount of the contribution from that source. These are the economic facts governing the arts which involve performance at a certain standard and on a certain scale.

The word 'standard' does not imply some airy concept. You cannot, in difficult times, cut four players from the string section of an orchestra and three from the brass, and expect the public to come in the same numbers. The sound will suffer.

But it is not enough to keep alive, or even to allow to develop what is already there. For one thing, the arts only reach a small section of the public. For another, artistic creation will never fit neatly into pre-ordained containers. And it is artistic creation which is at issue, nothing less;

and when it happens, and has some special quality, it needs to be nurtured and cherished. This is not a case of people demanding special treatment for the benefit of their own pockets, but rather of the need to keep alive one element at any rate in our national life which has, since the war, been outstandingly successful.

Public money evoked, as I have tried to show, a matching effort from artists and from representative citizens in many sections of the community, as well as a response from the public at large. But because the matching effort has been so great, and because so much of it has been unpaid or under-paid, the national achievement has been possible with a fairly small contribution from public funds. That we have had our arts on the cheap is clear from a glance at the figures showing the amount of public money provided in many other countries, often poorer than our own. The present sixty to seventy million pounds from national funds is a tiny sum in relation to what is spent each year on education as a whole, and to increase that base line figure to a realistic level would have a most productive effect not only on the quality of our life but even on the national economy. A small cut would be correspondingly destructive.

The thirty year period I have described may soon be seen as a Golden Age. At the time it seemed far from golden in any money sense but rather for givers and recipients alike a perpetual struggle to make do with very little. But having lived through it as a member of a number of receiving boards, and because later through my long association with the Arts Council I was at the giving end, I recall a certain glow of enthusiasm because small resources seemed always to evoke a wealth of effort, and because we were engaged in a reconstruction of our whole system of support for the Arts. And I am old enough to remember a very different situation before the war.

There are signs that we may be moving into less happy times. One is that there may not be enough money to keep the arts alive. The other, partly a consequence of the first, is that less money will intensify the scramble for a share in the cake and the demand for a say in the distribution process. It will certainly impose upon the bodies giving subsidy the need to make choices which hitherto, to the great benefit of the arts, they have been able to avoid.

Of course the Arts Council and the regional associations have always had to make choices - whether to give at all and if so, how much. But they have been reduced to a minimum and it has just been possible, as I have earlier tried to show, to respond to quality and enterprise whenever and wherever it occured. This in turn has been possible because the subsidising agencies have relied on advice rather than

direction, because of a constant awareness of what was happening, and because the giving was accompanied with care and concern.

I am aware of the difficulty of preserving the old close relationships because of the growth in scale and complexity, but I believe the subsidising bodies can and must between them solve this problem. They can only do so if Government continues to give them at any rate enough to allow the system to operate. A fall below a certain level will make this impossible.

In the war years and just afterwards a few people in or near Government circles saw how much might be done with very little. The response in effort and creativity has been phenomenal. Will their successors today have the same vision?

Sir Hugh Willatt

was Secretary General of the Arts Council of Great Britain from 1968 to 1975. He had been a member of the Council for some years before becoming its chief officer and before he joined the Council he was a member of its Drama Panel of which he eventually became Chairman.

He was active in promoting the arts in Nottingham where he practised as a Solicitor until 1959 and particularly in the creation of the Nottingham Playhouse, and eventually its new theatre.

THE MECHANISM OF THE ARTS COUNCIL AND SOME PROBLEMS OF POLICY

James McRobert

When I was invited to contribute to this publication I accepted, if not with alacrity, at least with goodwill. In spite of much that has happened to undermine my faith, it is still my firm conviction that it is part of the duty of a citizen in a democracy to keep his national and local institutions under constant and critical review and to modify, amend and discard as necessary. In fact a good case might be made out for winding up an organisation like the Arts Council at the end of a run of about thirty years and starting again. A shorter run would not give time for reasonable growth and development and in a longer period the process of ossification might have gone too far. In a sense of course, this always happens. Each succeeding generation slightly modifies the tools of the trade and alters the slant of the approach to old problems. The problems themselves change remarkably little.

I did not belong to the original band of heroes and heroines who braved the blackout and pioneered the way in the days of C.E.M.A. I came in with what might be called the second wave in 1946, just after the war. Something of the original pioneering spirit still survived. Where no suitable outside body existed, officers of the Council were prepared to go out into the field and do it themselves. This happened particularly in the field of the visual arts where the Council set up an organisation capable of touring exhibitions on a nationwide scale. It happened to a lesser extent in the field of music and the theatre where the difficulties were greater and it was more often possible to find outside bodies to undertake the work; although the Council did go into theatre management on more than one occasion. Literature had not yet emerged as an Arts Council subject[1].

In the original sense of the words, almost all the early employees of the Council were 'amateurs of the arts' although many had professional qualifications of one kind or another. But it was soon found that it was not possible to run the Council's business on the basis of part-time service. Painters, musicians, actors and singers who had, as it were, been 'seconded' from the world of the arts, were faced with a difficult choice. They could practise the arts in which they had been trained or learn the new business of art administration, but they could not, with any real hope of success, be at the same time both practitioners and administrators. Of course it did not happen in an orderly and carefully thought-out way, but this in fact was the practical outcome. Looking back, it is remarkable that the first generation of Arts Council administrators learned their trade so quickly and so successfully. I was spared the agonising choice. Although I gravitated to the Council after the war because I was deeply interested in the arts, I had been trained as a Chartered Accountant and it was as an accountant that my services were considered to be useful to the growing organisation.

The history of the birth of the Arts Council has been mentioned in previous essays and I will not repeat it here. The Council was incorporated by Royal Charter in 1946 and has since been accepted by the central governments as the official channel for subsidy to the arts[2]. For historical reasons, a number of 'art' institutions (chiefly but not exclusively museums and art galleries) continue to receive direct government grants and only an obsessive concern for administrative tidiness would seek to bring them under a single authority; but new applications in the art field would now normally be referred to the Arts Council.

The Arts Council grant is included in the vote of the Department of Education and Science. A Junior Minister in the department has usually been given 'responsibility for the arts' and he or she, among other duties, speaks for the Arts Council in Parliament when required to do so.[3]

The Council is a peculiarly British hybrid and probably some account of its structure and machinery is called for at this point. The members of the Council, originally appointed by the Chancellor of the Exchequer have more recently been appointed by the Secretary of State for Education and Science after consultation with the Secretaries of State for Scotland and Wales. They consist of a chairman, a vice-chairman and eighteen other members. The chairman and other members are appointed as above by the Secretary of State, but the vice-chairman is appointed by the Council, with the approval of the Secretary of State, from among its own members. With the approval of the Secretary of State for Scotland or the Secretary of State for Wales, as the case may be, the Council appoints a committee for Scotland and a committee for Wales, now known

respectively as the Scottish Arts Council and the Welsh Arts Council. The chairmen of the Scottish and Welsh Arts Councils appointed with approval as above, are members of the parent Council in London, and although it is not laid down in the Charter, it has become a matter of traditional practice that three members of the Scottish Council (including the chairman) and two members of the Welsh Council (including the chairman) shall be members of the parent body. The Scottish and Welsh Councils, although embraced by the parent Council under the Charter, are virtually independent bodies within their own borders, and when the total grant-in-aid has been apportioned between the three countries by an estimates committee (on which Scottish and Welsh members serve) the Scottish and Welsh Councils administer their separate funds without interference from London. Devolution may of course eventually alter this, but the present system, while securing freedom of action in Scotland and Wales, maintains a useful amount of consultation and liaison.

Members of the three Councils and members of the Panels (of which more later) are unpaid, but they may be reimbursed for out of pocket expenses when engaged on Arts Council business.

Council members are appointed for their personal qualities or qualifications and not as representatives of any other organisation or group. The chief executive officer, the Secretary-General, is appointed by the Council with the approval of the Secretary of State for Education and Science but neither he nor any other member of the Council's staff is a civil servant. A member of the Council is appointed in the first place for a term not exceeding five years. At the end of this term a member is not eligible for re-appointment until after the expiration of one year unless (and this is an important proviso) the member is the chairman or vice-chairman of the main Council, the Scottish or the Welsh Council or the chairman of one of the Panels. Obviously an attempt has been made here to hold the balance between the value of experience and continuity and the benefits of an infusion of new blood at fairly frequent intervals. No one has ever succeeded in inventing a formula which completely reconciles these two conflicting requirements, the personal factor so obviously governs the case in practice, but in my experience the Arts Council system has worked reasonably well.

Probably however, the most important piece of Arts Council machinery is the Advisory Panel. The Council is empowered by its Charter to appoint Panels to 'advise and assist' in the exercise of its functions and the chairman of each such Panel must be a member of the Council. As in the case of Scotland and Wales this ensures close and continuous liaison. A Panel is set up to cover each specialist subject and at the present time (1979) there are four: Art (i.e. the visual arts); Drama; Literature;

and Music (including Opera and Ballet). Each specialist subject is also covered by a section of the Council's staff under a suitably qualified director who acts as secretary to the Panel dealing with the same subject.

Committees have been set up to pursue special enquiries and deal with sub-divisions of the main subjects, but the basic Panels have now survived and proved their value for many years.

Members of the Panels are chosen for their professional knowledge of the subject concerned. For example, members of the Drama Panel might be actors, actresses, theatre directors, theatre managers, playwrights, university lecturers in Drama and so on. They are normally appointed by the Council for three or five years, but there is no limit laid down as far as the term is concerned, and the size of the Panel is not limited.

There is a two-way traffic between the Council and the Panels. Problems may be referred to Panels by the Council for advice and Panels may initiate new subjects for discussion and recommend subsidies, but they are not empowered actually to vote money. Although members of the Panels are not restricted as ordinary members of the Council are, by rules as to re-appointment, there has in practice been a considerable turnover in membership. Since the earliest days hundreds of public spirited citizens have given this unpaid service to the Council. An organisation like the Arts Council must of course employ a properly paid and properly qualified staff to carry on its work, but it should not be forgotten that it is helped by a vast amount of unpaid service. This is important not because it saves the tax-payer's pocket, but because it brings freshness of interest to the Council's work and a wide professional experience to the unravelling of the Council's problems. This kind of specialist public opinion also keeps the Council in touch with what is happening in the art world in which members of the Panels live. The Scottish and Welsh Councils appoint their own Panels on the same lines as those in England.

Clearly most of the problems of a government-sponsored body arise from a shortage of money. At any given time, what the Council considers to be its reasonable needs and (*a fortiori*) what the Council's dependants consider to be their reasonable needs will be far in excess of the Council's current resources. The demands are virtually limitless; the means to meet them will always be limited. Nevertheless, the rise in the amount of the funds made available to the Arts Council has been substantial by the standards of government thinking in such things.

The late Lord Esher once said that all governments are philistine, a statement with which I suppose few will disagree, but in fact, no government between 1945 and 1978, whatever its political complexion, cut back the subvention to the Arts Council although there was a standstill in the

years 1950/51, 1951/52 and 1952/53 (complicated by special provision for the Festival of Britain) and again in the years 1953/54 and 1954/55. This, I think, is a remarkable record in a country with no long tradition of public support for the arts. A part of the increase is of course due to inflation and at the present time there are unusually severe restrictions on government spending, but even so considerable net progress has been made.

I am far from believing that enough is being spent on the promotion of the arts, but in a democratic country public opinion must be convinced if funds are to be forthcoming. In the comparatively short period of thirty odd years, the Arts Council has had some success in extracting funds from the public purse and educating public opinion to that end, but much greater sums will be needed in the future. Even at the lowest political level, the importance of the subject can hardly be exaggerated. It can already be seen that leisure is likely to increase during the next few decades to the point at which it becomes a social problem. We are clearly at the beginning of an era when increased leisure will be forced on us by technological developments and we cannot spend all our time watching professional football or even watching snooker on the television screen - a fascinating entertainment though this may be. These are not the highest motives for the support of the arts, but they deserve sober consideration by any government.

An Arts Council cannot of course create works of art. It can only help to provide tools and materials and work to produce an environment in which art and artists may flourish and the public may be brought to enjoy the delights which the arts can give. Bluntly, this is done for the most part by the discriminating application of money. It would be an oversimplification to say that the Arts Council is nothing more than a banker; its accumulated expertise is valuable and it is often able to give useful advice, but banking is a part of its function and perhaps, drearily enough, the most important part.

The Arts Council is a sort of buffer state between the responsible Minister in Parliament and his public critics, and so affords him some protection, but why has this particular method been chosen? Why an Arts Council and not a Ministry of Fine Arts, or if the net is to be cast wider, a Ministry of Culture and Enlightenment or a Ministry of Leisure? The Arts Council (or more accurately its predecessor C.E.M.A.) was started, as so many things in this country have been started, by a group of likeminded people coming together and, first with private money[4], and later with a small amount of help from public funds, setting up an organisation to provide something which they regarded as an important service

51

to the public. Museums and art galleries, libraries, nursery schools, public baths and public wash-houses have all been started in a similar way. The normal course of development is that the service, when it has proved its value, is taken into the public domain and finally becomes the responsibility of a municipal authority or a Minister. But here the case has not developed on the usual lines.

From the beginning it has been argued by supporters of the Arts Council idea that a Ministry would be undesirable for a number of reasons. It would (it was said) import an element of politics (perhaps even party politics) with possibilities of direction or censorship and in the present state of the world, this seems less unlikely than once it did. It would saddle the whole operation with a cumbersome apparatus of bureaucracy and it would inhibit any adventurous or imaginative use of funds. A Minister with direct responsibility would be constantly bombarded with arguments of the 'fair shares for all' variety which often make very little sense in the world of the arts, and his civil servants would be faced with decisions which cut across the grain of their training.

However enlightened and sympathetic an individual civil servant may be, there is a heavy moment of inertia in the working of any large bureaucracy. Decisions take longer; precedents must be checked, the position of the Minister must be carefully safeguarded, and a constant effort must be made to avoid inconsistencies and risks. These are virtues in a civil servant and the excellent civil service in this country would be damaged if they were abandoned. But risk-taking is part of the everyday business of an organisation like the Arts Council and from time to time it must be prepared to face charges of inconsistency. Concert promotion and the theatre are high risk undertakings, particularly when new work is concerned, and the wilder shores of modern art will always arouse controversy. An Arts Council must be free to risk money, even by ordinary commercial standards to *waste* money, in backing new ventures and outside chances. This is no work for a civil servant charged with the wise spending of public funds.

Obviously the Council should be accountable in retrospect for the money it spends, but it should be free from day-to-day government control, and it should be allowed a wide latitude. But, and every statement about the Arts Council invites a 'but', the wider the Council spreads its boundaries the more difficult it is to defend the kind of freedom it now enjoys and the stronger become the arguments for a Ministry that would in fact find itself dispensing social services rather than promoting the arts.

Partly of course, it is a matter of money. While the sums involved

52

were relatively small, public interest in the vagaries of the Arts Council was fairly minimal, but with larger grants has come more interest and, quite rightly, more criticism. To define the limits of the arts is an impossible task; the boundaries shift and the markers get up and walk away like Alice's croquet hoops, but for an organisation dealing with public funds some guide lines are necessary, however often they may have to be redrawn.

It is easier in practice to decide what to exclude rather than what to include. In the pioneering days of C.E.M.A. and the early years of the Arts Council certain rules were evolved which, although they might be justified by arguments of principle, were to some extent dictated by lack of money. By and large the Council decided not to subsidise amateurs, direct educational activities, or commercial enterprises which were considered to be barred by the Council's constitution.

The Council by the terms of its charter was constituted a charity and as a charity could only use its funds for charitable purposes. This led to the promotion of a number of limited companies (chiefly theatre companies) which qualified under the law as charities. In these cases the Memorandum of Association provided the company with a charitable objects clause: a further clause prohibited the distribution of any profits except on winding up and then only to a charity with similar objects. Companies of this kind, if they were otherwise considered to be worthy of support, were eligible to receive financial help from the Arts Council. They were also able to apply for exemption from entertainments duty in the days before that tax was abolished. This is not the place to examine the legal arguments. I know that there would be difficulties from the point of view of the Inland Revenue, but it is question whether the legal definition of a charity should be reconsidered, or whether the Arts Council should now be prepared to enlarge its scope even at the cost of abandoning its claim to charitable status. If, for example, the Council became involved on a large scale with the commercial theatre (not at all an unlikely development) then the matter of charitable status might become a live issue.

It is also a question whether the Council should examine its position as far as education is concerned; education that is as an object for Arts Council subsidy. I'm sure the Council does not regard education, even adult education, or education in the arts, as a prime responsibility but there is a constant temptation to stray across the borders in this area and perhaps it should be resisted. After all a Ministry already exists to deal with the subject. Demonstrations and lessons in art appreciation are surely a matter for the schools, and the training of artists, in so far as

London Contemporary Dance Theatre takes part in the Dance Artists in Education scheme at Wakeford School, Havant, Hants., giving 'Demonstrations and lessons in art appreciation.' Photo: Chris Davies.

this is possible, is a matter of technical education. At some points there may be difficulty in drawing a clear line of demarcation, but definitions are easier here than in some other departments and I don't think problems in the field of education can be solved in a satisfactory way by giving more money to the Arts Council.

The exclusion of the 'amateur' raises questions of a different kind. I do not under-estimate the importance of the amateur movement in the arts. I think it is of the greatest social value and the field covered is enormous, but to make it a responsibility of the Arts Council would lead, I think, to a confusion of aims. Here again we are dealing in the main with border disputes. The Council uses its funds (generally-speaking) to promote the professional arts but by way of the regional arts associations it is being brought into closer and closer touch with the amateur and this is a trend which is likely to continue. The interests of the amateur would, in my opinion, be better served by putting them into the hands of a separate government-sponsored body, perhaps on the lines of the Sports Council, which would work in close co-operation with local authorities. It is at the local level that the amateurs commonly make their contribution and it is at the local level that their needs can most accurately be assessed. Without distinctions of function on some such lines, I think our feet may be set on the road which leads in the end to a Ministry with terms of reference far wider than anything the loosest definition of the arts could contain.

This might of course not be an unmitigated disaster. In a Ministry, differences which I see as difficulties for a body like the Arts Council, can be accommodated after a fashion, on departmental lines, but I think something would be lost if the Arts Council were dismantled.

In suggesting that the arts should be distinguished from leisure time activities in general and from education, I am not trying to save money on the Arts Council budget. As we learn to arrange our affairs in more civilised ways we must be prepared to face expenditure in this field on a much grander scale. On the assumption that the central government will recognise its duty in the matter, the Council must be ready to spend much larger sums than in the past on co-operative enterprises with local authorities, including building projects. It is written into the objects clause of the charter that the Council shall advise and co-operate with . . . local authorities and other bodies on any matters concerned whether directly or indirectly with . . . (its) objects'.

There are many examples of fruitful co-operation between local authorities and the Arts Council. All the great provincial orchestras and all or almost all the repertory theatres in the provinces receive financial help from both the Arts Council and local government, but over the country as a whole, the results have been patchy. The place of local government in promoting the arts and making provision for leisure activities, I think is much more important than has so far been recognised. This is a proper sphere for local initiative and should be a matter for local pride, but it calls for a good deal of financial courage on the part of both the local councillors and the rate-payers.

Before the Local Government Act of 1948, the power of a local authority to spend money on the arts was restricted. The acts of 1948 and 1972 removed most of the restrictions but did not notably loosen the purse strings. (Table 3 shows the gradual increase in total Government expenditure on the arts in the last decade). The 1948 act empowered local authorities to spend, on what might be loosely described as the arts[5], sums not exceeding the product of a sixpenny rate (2½p. new style): the 1972 act removed the financial limit. These acts were permissive and not mandatory and they have not produced a very encouraging outflow of local government funds to advance the arts. In times of financial stringency local authorities find it easier to cut expenditure under this head than in almost any other department.

There is one rather odd exception to the general rule that prior to the 1948 act local government authorities made little provision for the arts. That exception is in the field of visual arts. In the nineteenth century art galleries were built in extraordinary profusion until in fact almost

Table 3

Government Expenditure on the Arts in Britain 1968/9 - 1978/9

£m 1979 survey prices	1968/9	1969/70	1970/71	1971/72	1972/73	1973/74	1974/75	1975/76	1976/77	1977/78	1978/79
National Museums and Galleries	23	23	26	32	27	30	35	37	38	37	45
Local Museums and Galleries	20	16	18	22	25	30	36	36	33	33	34
Libraries (National and Local)	166	181	194	210	230	246	255	252	251	246	249
Arts Council and other arts	72	68	80	94	98	107	128	124	129	128	143

NOTE This table does not include such expenditures by Government as the costs of maintaining historic buildings and ancient monuments (estimated in excess of £20m in 1978/9) or the costs of maintaining the 79 staff and regimental bands in our armed forces (also estimated to be a cost in excess of £20m).

The total Government expenditure in 1978/79 was more than £62,000 m.

every town in the country, of any size, possessed one and they remain to this day solemn public monuments in most provincial towns. It is hard to account for this particular artistic preference in Victorian city fathers, although it has been suggested that large pictures in heavy gilt frames were not only considered to promote civic dignity but were also considered an excellent investment for civic funds. Some have indeed shown such a satisfactory rate of capital appreciation that in one case reported recently a local authority seriously considered a proposal to sell some of the pictures in the municipal art gallery to avoid an increase in the rates.

Apart from the national treasures in London, Edinburgh and Cardiff, many of the provincial galleries, of course, house important collections, but the galleries are often under-used and under-valued by the citizens who own them. Here is a useful area for co-operation. With the help of the Arts Council municipal galleries can be enlivened and made more attractive to visitors in various ways without alarming expenditure; by taking in travelling exhibitions and offering an auditorium for lectures, music, poetry recitals and so on.

A third source of revenue for the arts, I see as something of a bonus. To some, as yet fairly limited, extent commercial and industrial corporations have taken the place of the old private patrons. They have commissioned paintings and sculpture to adorn their premises and from time to time they have been persuaded to sponsor performances or exhibitions. The motives may be prestige or publicity but in this the new patrons differ very little from the old and I can find no objection to the motives if the end result is the production of work of genuine merit. In fact I would be prepared to support tax concessions on the American pattern to encourage this kind of expenditure. I would also like to see the big trades unions and the nationalised industries prepared to make a contribution, and not simply in the way of buying 'old masters' as a hedge against inflation for pension funds.

But when the money has been raised, it must be laid out to the best advantage and the difficulty of subsidising the arts varies from subject to subject. At one end of the spectrum are the so called 'performing arts' - music, opera, ballet and the theatre - which absorb vast quantities of public money in subsidy, but in many ways present the easiest problems to the Arts Council. At the other end are individual artists - painters - sculptors, writers, composers and so on. Here the Council is faced with a much more difficult exercise. The sums involved in prizes, commissions, bursaries, purchases, travelling scholarships and such kinds of individual help are not large, even in aggregate, but the problem of devising a system which will be accepted as fair and even-handed and will at the

same time encourage the production of good and interesting work is considerable. In fact no system can ensure this and no machinery however carefully designed, is likely to remove from the mind of the disappointed applicant the suspicion that the whole thing is a contrivance by which money is channelled into the pockets of 'friends of friends' or fashionable practitioners of the moment. I suppose the most convincing counter to such a suggestion, if it were taken seriously, would be that the awards have never been large enough to make such arrangements worth while or even likely, but it remains true that subsidy to individuals presents problems to a state-supported body like the Arts Council.

Commissions at second hand are one way out of the difficulty. The Council offers a grant to (say) a theatre management which enables the management to commission a play, or an opera, or ballet, or designs for scenery, or whatever else. The artist is chosen and contracted by the management and, in addition to the original grant, the Council may provide a guarantee against loss for a series of performances.

In the art department the Council took the bull by the horns when faced with the problem of purchasing contemporary works of art or works from the recent past. Originally a single purchaser was appointed for a period of one year; often, though not necessarily, a member of the Art Panel. A sum of money was placed at his disposal and he was allowed to buy on behalf of the Council, with complete freedom up to the limit of the funds in his hands, consulting his personal taste or taking advice as he thought fit. At the end of the year a new purchaser was appointed. In present practice several purchasers may be appointed during the year and sometimes a purchaser may work to a particular brief, such as buying material for a projected exhibition. By these means an interesting and varied collection of modern work has been built up. It is used to furnish travelling exhibitions and loan exhibitions to local authority galleries and others, and occasionally it provides sculpture for open air exhibitions.

In the department of literature it is still a moot point whether the Council's funds are better employed in prizes and bursaries to authors, or in working out financial arrangements with publishers to secure the publication of work of merit which might not otherwise get into print. Both methods of dispensing help are used and the permutations have not yet been exhausted.

In this paper I have deliberately refrained from describing the work of each department of the Arts Council in detail. Within the total organisation there is a good deal of departmental freedom but at some point the threads must be drawn together and, in fact, the heads of departments

'. . . sculpture for open air exhibitions . . .' Elizabeth Frink's 'Horse 1978' at the 1978 Hayward Annual (Arts Council of Great Britain)

meet once a week to exchange views and examine current problems. In the early days the meeting was a very informal affair and no records were kept, but it has grown, in the usual way, into a formal occasion with the Secretary General or his deputy in the chair and a minute writer to record the proceedings. It is a useful institution. It ensures the kind of personal contact between senior members of the staff which produces a feeling of mutual support and makes them aware of the common problems that straddle departments.

Administration, whether of the arts or anything else, is not an exact science. It is a matter of estimates and approximations, more or less informed guesses and constant adjustments. There are no universal

solutions. Only the most superstitious believe in perfect plans. Perhaps one can say there should be a certain fluidity in good administration - a willingness to accept change - but if an organisation is not to collapse into chronic indecision, there must also be enough stiffness to reject when it is considered necessary. This kind of ambivalence is a management problem in any field, but it seems to present itself with peculiar force in the art world. In the end it can only mean that management must be prepared to make decisions and make mistakes and it must not be worried overmuch if it is charged with inconsistency.

Methods will change inevitably, the emphasis will shift, fashions will come and go, but certain questions are recurrent. How is one to avoid turning those in receipt of government bounty into passive pensioners? How is one to stimulate enterprise and enthusiasm and keep alive the growing points of the arts? How, in other words, is one to avoid hardening of the arteries?

As always, there are more questions than answers. Large organisations in the world of 'performing arts' need large maintenance grants to keep them afloat. There is ample evidence that they cannot live on the receipts from the box-office even when attendances are consistantly good. They may occasionally be tempted to experiment or take risks by the offer of a guarantee against loss to cover a particular venture, but this device has never proved very popular, although in the form of commercial sponsorship it seems to be perfectly acceptable. They may, as I have indicated earlier, be encouraged to commission writers, or painters, or composers, if the contract is underwritten by the Arts Council or some other sponsor, but, in the main, the newest and most experimental work will be done elsewhere.

Clearly it is part of the business of the Council simply to keep the doors open and provide employment for artists. There must be established centres in London and the provinces to maintain standards and to keep the classics well furbished and constantly in the repertory. There is always someone in the audience who is seeing King Lear or hearing Beethoven's Fifth Symphony for the first time. But when this has been done, finance permitting, as well as it can be done, there remains the final and most difficult question. Experimental work is likely, on the whole, to be produced by small 'avant garde' groups and it is in the nature of things, in the art world as elsewhere, that there will be a heavy rate of mortality in the advance guard, but the Council must not shirk its responsibilities in this field, however difficult the decisions may be. It may be true, as a matter of statistics, that in any given period more bad art will be produced than good, but the search must go on.

60

At the present stage of its development however, it seems to me that the chief danger for the Arts Council is diffusion of effort. Diffusion in the sense of a spread that is too wide and too thin, and in the sense of an expansion into areas that have only a remote connection with the objects for which the Council was established.

Bernard Berenson said something to the general effect (I don't pretend to quote) that if a man is really interested in art, he should be prepared to climb on his hands and knees to a monastry half way up a mountain, to see a picture. More recently it has been said that the Arts Council is 'a village store trying to serve a society which expects the services of a super-market'.

There is a certain paradox in the Arts Council position. It is charged by its charter: (a) to develop and improve the knowledge, understanding and practice of the arts and (b) to increase the accessibility of the arts to the public throughout Great Britain. The ideas do not contradict each other, but they can produce conflicts of policy. While the Council must accept that it has a duty under the charter to serve the buyers in a large popular market, or at least attract their attention, it helps no one to suggest that the Arts Council can supply the arts in neat packages to all comers: that it is able, as it were, to supply "convenience foods" to those unwilling to take the trouble to cook.

I believe the Arts Council should concentrate its efforts, at least to the extent that its funds are directed to the support of the professional artist and the dissemination of his work. It should eschew peripheral activities which can and should be undertaken by others. There is no danger that this concentration would be unduly restrictive. There is so much to be done that it cannot be covered by the present scale of government subsidy, but it helps to clear the mind if there is some limitation of aims.

NOTES

1 Following a poetry competition organised by the Council to mark the Festival of Britain, a Poetry Panel was set up in 1951. In 1964 the Panel was enlarged and its scope widened to cover Literature in general.

2 The original charter was dated 9th August 1946. It was amended by the Secretary of State for Education and Science Order 1964 and the Transfer of Functions (Cultural Institutions) Order 1965. A new Charter replacing the original was granted on 7th February 1965.

3 The Conservative Government of 1979 has a full Cabinet Minister responsible for the Arts.

4 The initial grant came from American funds, from the Pilgrim Trust.

5 The Local Government Act of 1948 provided that:

 (a) A Local Authority may do, or arrange for the doing of, or contribute towards the expenses of the doing of, anything necessary or expedient for any of the following purposes, that is to say:

 (1)The provision of an entertainment of any nature or facilities for dancing:

 (2) The provision of a theatre, concert hall, dance hall or other premises suitable for the giving of entertainments or the holding of dances:

 (3) The maintainance of a band or orchestra;

 (4) Any purpose incidental to the matters aforesaid, including the provision, in connection with the giving of any entertainment or the holding of any dance, or refreshments or programmes and the advertising of any such entertainment or dance.

James McRobert C.B.E., F.C.A.

was born in London but spent much of his youth in Liverpool. He was articled to a Liverpool Accountant and qualified in 1927. His concern for the arts began with his involvement in the 'Little Theatre' movement and that, and his study of architecture, have remained lifelong interests.

After wartime service with thé R.A.F. here and in Egypt, he joined the staff of the Arts Council in 1946. He retired as Deputy Secretary and Finance Officer in 1971.

THE APPROACH TO ENGLISH LOCAL AUTHORITIES 1963 - 1978

Nigel J. Abercrombie

When I was interviewed for the post of Secretary General of the Arts Council of Great Britain, the late Sir William Emrys Williams asked me if I had any experience of dealing with local authorities. It was a predictable question to put to a candidate who had graduated from University teaching to the Civil Service, and had been in 'Whitehall' for more than twenty years. I had to say 'no'; but I knew that, if I were nevertheless appointed, this was going to be the root of the matter. My future staff would not need me to tell them anything about the arts; my up-to-date experience in the Cabinet Office would automatically be useful; my former masters in the Civil Service would prefer that the new Secretary General should sit at his desk and run the office, as I was trained to do; but, if 'W.E.'s' successor was not to let the side down, he must get out into the sticks. In the event, by retiring from the Civil Service to take on the new job, I was set free to follow this course.

By the happiest imaginable coincidence, I was given a flying start. Just before my appointment (to succeed a Secretary General who had held office for twelve years, after five years as a founder member of the Arts Council), the Association of Municipal Corporations had appointed Sir James Swaffield as Secretary (in succession to a gentleman who had been in the post for eighteen years). We had never met; there was an age gap between us of nearly sixteen years; nobody would have thought there was anything in common between us (except, indeed, the Navy). But we were both potentially 'new brooms'; and whereas his civilian experience was in the field, of all others, in which I knew myself to be most incompetent, my position was at the heart of what he knew was the least-developed part of his business. So he invited me to take a leading part at the first Annual Conference he organised, of the

Association of Municipal Corporations (in September 1963); this was a daring innovation.

The whole of the first day of the Conference was devoted to 'Local Patronage of the Performing Arts': it seemed successful at the time, and I have been told since by a senior member, I believe correctly, that it was a 'turning point'. Not in the sense of a reversal of direction, but as though a tide, which had then scarcely begun to show visible evidence of moving at all, was afterwards found to be swelling. (Of course, from my personal point of view, the occasion was even more dramatic: from then on, I was in business with the town halls).

In 1963, there was no compendious source of information about the work and expenditure of local authorities in the field of the arts (the first survey by the Institute of Municipal Entertainment was then in progress). One had to go and see for oneself. By degrees, a pattern emerged. There was an anomalous chasm between Education and (what is commonly called) 'Culture': the former being the business of counties, and of a few rich boroughs, since Balfour's (or Morant's) Act of 1902. Subsequent legislation, and the trend of departmental practice, have increasingly centralised this business, so that it was already in 1963, and still is, exceptional to find a town library in which local initiative is suffered to impress any distinctive 'cultural' stamp upon the range of its activities. The great majority of the boroughs, on the other hand, derived their functions as well as their administrative shape from the Whigs' Municipal Reform Act of 1835, and had come to maturity in the heyday of Victorian liberalism (as so many town halls still visibly proclaim). With a modest degree of exaggeration, one could almost say that it is rather the rule than the exception for a borough (in the pre-1974 sense) to possess and manage a museum of sorts, with or without a (picture) gallery. In a few large towns, the Victorian tradition of cultural philanthropy persisted in the form of seasonal subsidies from the rates for professional orchestras, while a number of 'resort' towns employed musicians for the (profitable) entertainment of visitors.

All these elements of the Municipal scene had more than a half-century of experience behind them, with a corresponding measure, in some cases, of conservatism and decay. The atmosphere of the sixties in the English-speaking countries was favourable to cultural advance and development. A provincial gallery with, perhaps, a unique collection of works by Etty, or by Burne-Jones, ought, it was felt, to be more than a dormant piece of a city's patrimony: it should be a living part of the regional heritage. Young people should be brought to see the pictures, and taught to enjoy - even to appreciate - them. Temporary

exhibitions should be mounted with modern, sophisticated techniques of showmanship. Curators should be encouraged to acquire (if necessary) and display enthusiasm for their custodial and educational functions. All this costs money and effort, including the major enterprise of renovating and modernising premises. The work of the Area Museums Service, under the Standing Commission on Museums and Galleries, and the work (within narrowly prescribed limits) of the Arts Council as well, has all been undertaken in close partnership (financial and otherwise) with the local management and paymasters concerned. To initiate such a partnership, the instigators of progress need knowledge, zeal and tact - the more of each, the better; for the response depends upon the measure in which some influential persons on the other side can be persuaded and convinced of the real need for a change.

Quite another order of problems affected the position of the provincial orchestras. Two of these, established in the north, were already subsidised by a consortium of local authorities surrounding their quasi-metropolitan bases, and were thus 'regionalised'; a beginning had been made by the Western Authorities Orchestral Association to create a similar situation for the Bournemouth Symphony Orchestra. Here was a long-established 'resort town' band, which improved in size and standards to become a costly musical enterprise. There was an argument - of crystal clarity - to show that the people living in the catchment area of the south-west derived great cultural benefits from this development, and could fairly be asked to pay for it; but logic is not cash. Councillors from other authorities were well-placed to reject any proposal for subsidising 'Bournemouth'. This massive obstacle to regional support for locally-based activity became generalised during the Sixties and early Seventies. (In the south-east, quite recently, it formed part of 'a little local difficulty' between Guildford and Brighton . . .). Endeavouring to overcome or circumvent it in various parts of the country, one became very conscious of a special feature of local government in England, namely the *asymmetrical* pattern of political allegiances. Usually, the Labour group on a council behaves like a Westminster 'party', having formulated public policy on national lines, and a sense of party discipline, even 'whips'. The opposition to this group affects no such posture; its members are often shy of party labels, tending to be called 'independent', reluctantly accepting some organisation for the purpose of getting elected, perhaps as a 'Ratepayers' Association'. Across the board of public business (not 'policy') they are apt to concentrate their efforts towards the reduction of rates. In practice, therefore, it is sometimes easier to persuade Labour-controlled councils

into cultural initiatives than the other kind - not at all because Labour policies are arts-orientated, or because Tory councillors are philistines.

————————————— ✳ —————————————

Apart from art galleries and bands, the general legislation controlling the powers of English local authorities before 1948 discouraged expenditure from the rates on cultural projects, unless these formed an integral part of the formal schooling of children. A number of rich boroughs had secured private Acts under which they could and did (as I said in my address to the Association of Municipal Corporations in 1963) 'operate with great credit. All the same, the 1948 Act has a special political significance, apart from the special significance that it puts some emphasis on the performing arts; it is the occasion on which Parliament sought to give nation-wide extension to the initiative of the pioneering authorities, and it is the occasion on which Parliament established, at least provisionally, a kind of scale for the support of the

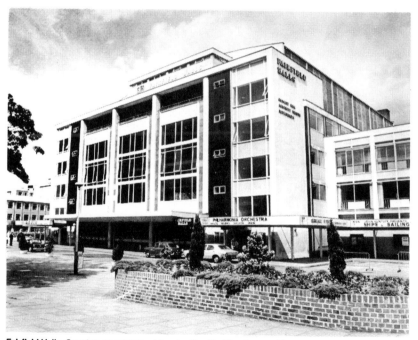

Fairfield Halls, Croydon, an example of 'local authorities' involvement' in the arts.
Photo: Frazer Ashford.

66

arts.' The most conspicuous development from Section 132 of Aneurin Bevan's historic Act was a proliferation of Civic Theatres: not, indeed, quite to the extent of Sir Alan Herbert's dreaded 'everywhere, ten miles from each other', but already all over the country. The kind and degree of the local authorities' involvement varied widely, e.g. from East-bourne, where they built a prestigious theatre to be hired out to more or less prestigious visitors, to Nottingham, where they largely controlled the management of a new resident company. In this context there first arises the possibility of yet another new kind of difficulty; because 'the social role of artists (on the assumption that they have one) is essentially critical'; theatre directors are professionally dedicated to artistic standards; and 'standards suffer as a result of lay and amateur meddl-ing'[1]. Throughout the period of fifteen years covered by this essay, the incessant risk of conflict between the social and political convictions of lay councillors and the artistic consciences of theatre people has ever and again erupted into crisis.

Against this danger it is tempting to apply the 'arms length principle' described by Lord Redcliffe-Maud in *Support for the Arts* (Gulbenkian, 1976). As he wrote, in the context of national government, 'a convention has been established over the years that in arts patronage neither the politician nor the bureaucrat knows best. It would be madness to . . . abandon this arms length principle'. But, like Ministers, 'locally elected representatives of the public must be responsible for deciding how much money should be forcibly extracted from *local* taxpayers for cultural purposes and how it should be spent. For most of them such exercise of arts patronage is something new, but until they learn from experience how to practice this gentle art and, in particular, come to recognise that the public only gets full value from public money spent on the arts if politicians, by a self-denying ordinance, keep themselves at arms length from the artists and art organisations that they subsidise, there is no future for arts patronage through local government'.

This is strong language; it is perhaps too strong. Certainly, extreme advocacy of an extreme form of the principle ('mind your own business') does alienate many councillors, including, notably those who are pre-disposed towards the arts and artists. Besides, the arts are not practised in a vacuum, or for the benefit of connoisseurs alone; why should counc-illors be denied access to artists? All my own experience suggests that the advantages to be gained from encouraging them to 'get their feet wet', as a regular policy, greatly outweigh the risks of unhelpful inter-ference. For example, councillors who have been suffered to live 'at arms length' from the *business* of professional artists can hardly with-stand the inhibiting fallacy of 'priorities' - drains, schools, swimming-

baths, housing, must take 'priority' over what is called 'culture', so public expenditure on the arts is 'irrelevant'. This untenable conclusion is buttressed by the fallacy of 'minority interest': it is of no use to tell councillors that, in 1977, '27 million fans paid to watch football matches; 34 million paid to go to the theatre,[2] if none of the voters they personally know about and meet regularly are theatre people. 'Support for the arts' comes from authorities in which elected members who have some first-hand acquaintance with artists' work and lives, can gain a hearing: as, indeed, Lord Redcliffe-Maud fully recognised when he wrote of 'learning from experience how to practice this gentle art'.

Nevertheless, the arms length principle, rightly interpreted, is of great value. It is our safeguard, in this country, against state art, municipal art, the political regimentation of artists, 'the patron, and the gaol'. If another line of defence is required, it might be provided by the Charity Commissioners, through whose beneficence nearly all subsidised cultural activities are tax-free: their rules should make both artists and councillors chary of showing political bias.

The formation of consortia of local authorities for the support of certain provincial orchestras on a regional scale has already been mentioned, with a suggestion that parish-pump loyalties had to be overcome in some instances. This was, at various times, noticeable among the southern counties, and in the midlands. In the north-east, a very different situation arose in the early sixties. The area which is now represented by the counties of Northumberland, Tyne and Wear, Durham and Cleveland possesses more of the distinct characteristics of a 'region' than are discernible in other parts of England. Social, economic, even sometimes political factors contribute there to a neighbourly cohesion, which is not seriously endangered by any such rivalries (dare one say jealousies? even antagonisms?) as divide - say - Merseyside from Greater Manchester, or some of the more southerly counties from one another. Thus it came about, even before 1963, that a North Eastern Association for the Arts (now Northern Arts) was founded 'to distribute monies made available by the local authorities' in this area 'and in particular to channel aid to the Northern Sinfonia Orchestra'[3]. This move inaugurated a development which has since ramified all over the country; it was quite new, unprecedented. (True, there existed 'regional' arts associations elsewhere in England; but these had no constitutional or

effective links with local government). At first, the Arts Council was less than enthusiastic. The North East Association derived its funds from the rate-payers under Bevan's Act, and there was a prejudice against using our Parliamentary grant-in-aid 'in relief of the rates'. It was only by degrees that the Council came to the conclusion that Bevan's Act had changed the basis of our relationship with local authorities, now that they were empowered - and actually willing - to operate directly in our field of action. Another reason for hesitation was that the new Association was more comprehensive in its aims that the Council, less rigidly concerned to insist upon professionalism in the subsidised arts, and ready to bring film and the crafts within its terms of reference. It is difficult now, seeing the fruitful relationships of the Regional Arts Associations with the British Film Institute and the Crafts Advisory Committee and the National Federation of Music Societies, to think oneself back into the categories of 1963, and to understand why the provision of £22,000 for Northern Arts in 1963/64 seemed prodigious (the comparable figure in 1978/79, admittedly including provision for Cumbria, was over three-quarters of a million pounds).

The North Eastern Association became the matrix of an official government policy in 1965, when Aneurin Bevan's widow, Jennie Lee (now Lady Lee of Asheridge) was appointed a Parliamentary Under-Secretary of State in the Education Department, and a White Paper was published under the title 'A Policy for the Arts'. In this paper, the North Eastern initiative was described, and the statement was made that a 'network' of such associations 'should be developed to cover the whole country'. Even without my severe bureaucratic training anyone could see the weakness of this piece of drafting - no one was made responsible for doing what 'should be' done; certainly not the Arts Council, which neither had nor wanted either a mandate or the resources for such responsibility. In practice, the first overt 'development' on the lines of the White Paper was the creation of an arts association for Lincolnshire - three administrative counties as unlike the counties of the North East, in almost all respects, as could be imagined: this was achieved by the untiring work of one private gentleman, a dedicated man of boundless enthusiasm. His persistent demands for advice from the staff of the Arts Council may not have brought him much assistance, but at least he was not discouraged, and we for our part were compelled thereby to do some belated homework.

The decade, 1964 to 1973, thus inaugurated by Lincolnshire, included the formation of ten Regional Arts Associations of the new style (that is, based on a partnership between the Arts Council of Great Britain and groups of English local authorities), at the rate of one a year overall,

until the whole of England was covered by this network. With hindsight, I reckon that half of these associations owe their origin to the initiative of private individuals who found their intrepid way into town halls and county halls, and into the Arts Council, and obtained their objectives by zealous persistence. Four more stemmed from the determination of people engaged in the business of local government, either as elected members of councils, or as salaried officers. The tenth, and chronologically the last, does not fall easily into either of these categories: its origins will be discussed later on. But as far as the North Eastern Association goes, and nine of its ten successors, the whole initiative was local. This rapid and effective regional response to a vague expression of a wish by the central government can, I believe, hardly be paralleled in the history of England in peace-time. I think it will be worth the attention of an historian, when this period can be seen in perspective. It was a time of severe financial stringency for local authorities, many of whom already spent handsomely on 'the arts' for their own ratepayers; a time, too, when the mere notion of collaborating with neighbouring authorities in new forms of expenditure was wholly novel.

Certainly the vigorous new development of regionalism in support of the arts was not due to any ebullition of crusading zeal from the Arts Council. Before 1965, our contact with local authorities was episodic (though frequent, and often friendly); it was not until 1968 that I was relieved of my duties as Secretary General and entrusted with the full-time responsibilities of a 'Chief Regional Adviser'. I had one enthusiastic and indefatigably competent assistant, Sheila Gold. For five years, we two were the Arts Council's regional staff. By 1968, I was acutely conscious of the need for professionalism in the whole difficult business of co-ordination between the Council's objects, as defined by the Royal Charter, and the needs and aspirations of town and county councils; also I had begun to learn something of the diversity of English local authorities - geographical, financial, social and historical. I had some of the tools in my hands, but what was the job?

It is always a pleasure to quote Lord Goodman, and two passages from his contributions to the Annual Reports of the Arts Council will help here. First, in March 1967: 'Artistic life in this country must not be dominated by a small, non-elected appointed caucus in St. James's Square. The avoidance even of the possibility of such domination is a conscious plank of our policy. Thus we encourage local plans and

promotions; thus we encourage the development of sensible regionalism'. Then, a year later: 'I do not believe that, with the immense present demand that exists in various localities, any other policy is a possibility; but it may be that, as time goes on, we will have to consider a change, and it was with this very much in mind that we decided upon the appointment of a regional adviser to give more detailed and systematic consideration to regional planning . . . in conjunction with the existing and prospective new Regional Associations'. It was in the year then under review (1967/68) that the importance of decentralisation, both for decision-making and for administration in the matter of support for the arts, was first distinctly emphasised (at an international conference of administrators held at Ditchley Park in July 1967).

In deference to the strongly expressed feelings of people who live outside Greater London, the words 'provinces' and 'provincial' have been dropped in favour of 'regions' and 'regional': but what, in England, is a 'region'? For various administrative purposes (Civil Defence, economic development, health services . . .), London had divided up the country into more or less convenient partitions at various times; but the centres and the peripheries of these so called 'regions' did not coincide and were in very few cases appropriate for an autonomous artistic administration. As long as the creation of a new Association came about through the spontaneous determination of a group of like-minded local people and co-operative local authorities (as in the North East, and Lincolnshire), the shape and size of the region and the location of its centre were easily defined; and the pre-existence of 'old-style' arts associations in the South West and Midlands helped to crystallize the new-style (local authority based) regions into which these developed. Even in this latter case, problems arose: Gloucestershire had affinities with the South West, rather than with the West Midlands, but Cheltenham seemed inconveniently remote from the existing headquarters of the South Western Association at Exeter; the solution there might have been to create a new Thames Valley region, which would then accommodate Oxfordshire and perhaps even Buckinghamshire (which is, I understand, still only 'regionalised' in part). But Berkshire was already looking South: and besides, we in London were still, in the sixties, fanatically devoted to a doctrine of non-intervention; the associations must be left free to determine their own boundaries, in negotiation with each other and with the counties and boroughs concerned. This was not always easy: I cannot look back with much complacency on the exercise of my advisory function when I think, for example, of Merseyside, or of West Sussex - let alone Buckinghamshire.

By the seventies, 'the approach to English local authorities' was developing into a kind of programme. In 1970/71 the Arts Council almost doubled its grants to regional associations. I was able to put forward a persuasive argument in discussion with representatives of Councils that still questioned whether the value of a regional association, for their ratepayers, would be worth the money (then calculated as a small fraction of 'a penny rate'): experience now showed that in every case the Arts Council's annual grant to an established regional association would be at least equal to the total of the ratepayer's contribution - and this as 'new money', over and above the Council's undiminished, nay increasing, subsidies for existing enterprises in the region. A return of 100% *per annum* was a useful card to play in negotiations, as I found with some satisfaction when talking to officers, and chairmen of committees, during the build-up of the new associations projected for the West Midlands, Eastern and Southern Regions.

Another well-motivated doubt in the minds of responsible councillors was whether the funds to be subscribed by one authority would not be used, by a regional association, mainly for the benefit of people living in the area of another - were the Norfolk ratepayers to find themselves subsidising the arts in East or West Suffolk? In principle, nothing would appear more likely: though the fact of the forthcoming massive support from the Arts Council in London might be expected to mitigate the damage. In practice, on the other hand, as could be demonstrated from an excellent analysis initially carried out by Southern Arts, things did not work out that way at all. Almost without exception, the subsidies provided by the associations for artistic events in the area of each subscribing member-authority amounted to more (taking one year with another) than the authority's own subscription.

These arguments, and others similarly based on visible facts, served to counteract a natural reluctance of local authorities to embark on a new kind of expenditure at a time when government policies, and inflation, were causing a new 'financial stringency' (are there ever any other times?). Other, and more sophisticated, lines of questioning came into prominence as the movement towards regionalisation reached its climax. Were the people of Yorkshire really any the better off, culturally, for the formation of the Yorkshire Arts Association in 1969? Now that Birmingham was becoming the new administrative unit called West Midlands, what useful purpose was the West Midlands Arts Association serving, to justify the overhead expenses of a distinct organisation? And why should the Arts Council attend so closely to the capitation fees of local authorities in membership of a regional arts association, ignoring the ratepayers' considerable traditional support of major artistic enter-

prises that were independent of the new-fangled 'network'? Perhaps it is surprising that this complex critical reaction against the doctrine of the White Paper of 1965 took so long to mature. (Perhaps, too, it is important to observe that the emergence of these doubts had nothing whatever to do with the reversal of party fortunes at Westminster in 1970. I heard them expressed more often and more cogently by people of socialist affiliations than by any conservatives; and, so far as the central governments' party machines were concerned, there was absolutely no hint of resiling from the 'regional' part of a cultural policy which had largely become 'bi-partisan'.)

However hard one may try, in London, to appreciate provincial experiences and opinions - and we did try; we didn't sit at our desks much, it doesn't work - it was not until I retired into the heart of one of the 'regions' myself that I began to learn the answers to this last group of questions. It was a particularly interesting move, because I had taken more of a leading part in the formation of the South Eastern Arts Association than anywhere else: it was the last of the English regions to be 'organised', and I had long held the view that its area (Surrey, Kent and East Sussex) was not a 'region', only a dormitory extension of the Great Wen. In the end, it was an (appropriately dramatic) intervention, at a big public meeting, by an uncommitted actor-manager who happened to walk in, that secured the crucial majority decision to go ahead with the projected association, after all its professed advocates and I had shot our bolt against an opposition founded on all the questionings listed in the last paragraph.

Now that I have first-hand local knowledge, the point about 'the overhead expenses of a distinct organisation' can be seen for what it really is. By a conventional method of accounting, quite a substantial part of the income of the South East Arts Association is recorded as being spent on "Administration and Services". That sounds like overheads; but I know that most of the salaries, and the bills for printing, postage and telephones, transport etc. are at least as directly productive, for the primary and essential objects of the Association, as any subsidies paid out for concerts, plays or art exhibitions. A more refined system of accountancy would show that the genuine overheads are simply negligible (about $3\frac{1}{2}\%$ in 1978).

Then, after some five years, are we in East Sussex really better off, culturally, through the work of South East Arts? Living in a village and having close personal contacts in other rural communities, I know we are. Professional theatre and dance are brought to our very door-steps, whereas, four years ago, there was no professional theatre to which, from a great part of the region, physical access was even tolerably

convenient. The audiences are mostly delighted, and the co-operation of amateur drama societies for effective local publicity, etc., is an even more welcome indication of genuine value for money. South East Arts is already earning widespread respect, as well as gratitude, for systems of selection to identify the most promising young artists and craftsmen in the region, and for the critical precision with which grants, bursaries and prizes are awarded, on an increasingly generous scale. Within my own experience I know of established musical enterprises being enabled to survive dangerous financial crises, and of others being revitalised; at the other end of a scale, sporadic ventures in 'community arts' are fostered with judgement based on *intimate* first-hand knowledge.

All this kind of work is characteristic of the new partnership between local authorities and the Arts Council: achievement and progress alike depend entirely on that (though the growing involvement of 'business' in the private sector has been and can be a valuable stimulus). It would be an indication of apathy if there were no differences of view and approach between the partners. In fact, the Arts Council has regularly called for greater contributions from the local authorities, aiming at a rough equality of investment on each side. Against this, the local authorities have shown that their total expenditure in support of the arts substantially exceeds the amount of their subscriptions to regional associations, which are only one element in their cultural programmes and budgets. At the time of writing, I was told by an experienced county councillor that local authorities generally tend to take a more active interest in voluntary associations when their statutory activities are being squeezed: this particularly applies to areas like the South East, which have been financially penalised by the central government for the benefit of the urbanised and industrial areas to the north. It may be that the imbalance of which the Arts Council complains is being gradually rectified. Certainly the constant collaboration of local authority representatives at all levels in the day-to-day work of South East Arts is already more effective than I, or I think anyone, could have imagined possible fifteen, or even five years ago. They are indeed 'learning', and learning fast, 'how to practice the gentle art of patronage'.

In drawing upon my own experience for the foregoing reflections, I have of necessity confined my attention to the South East in the period since 1973. The Arts Council's 33rd Annual Report - *A Year of Achievement* - contains (on pages 10 - 12) a comprehensive and lucid account of the Council's approach to English local authorities, and local education authorities, over the whole country at the present time. I doubt if the mature policy of the Arts Council has anywhere been better formulated:

'The . . . programme of Regional Development will not be complete, even its first phase, until each local authority has recognised its responsibility to its Regional Arts Association and has acknowledged the need for supporting the arts, both directly and through the Association, within its own boundaries'.

NOTES

1 N. J. Abercrombie - Artists and their Public (UNESCO, 1975)
2 Arts Council's Annual Report for 1977/78.
3 Redcliffe-Maud, op. cit., page 89.

Nigel Abercrombie M.A.,D.Phil, (Oxon)

taught languages in Universities before the Second World War. From 1940 to 1963 he was a senior civil servant in the Admirality and the Cabinet Office. In 1963 he began ten years' work with the Arts Council, first as Secretary General and later as Chief Regional Adviser. In retirement he continues research and writing, and is Vice-President of South East Arts.

THE ACHIEVEMENT IN DRAMA

N. V. Linklater

In this essay I refer to the Arts Council as having 'encouraged' or 'done' because the Council alone is the executive body. Nevertheless it is essential to recognise that in most cases, as James McRobert explained earlier in the book, effective action would have been taken beforehand by the Drama Panel. The Drama Panel, and its committees set up for special purposes, did the professional work - studying applications, visiting theatres, seeing performances, reading new plays, looking at the work of young designers, interviewing candidates for training schemes and so on, and finally making a judgement and recommending a course of action. The Council's officers naturally have some influence on Panel thinking and decisions and thus also effect Council policy. Although the Council responds to need, new initiatives often came from the Council - but these initiatives only made financially possible the new creative achievements of the companies themselves and of the artists and managers who worked in them.

What, in the field of drama, has the Arts Council done that otherwise would not have been done: what especially has it achieved? Taking this as the basis of my essay, I believe that its exceptional achievements, which would not have been accomplished either by direct government subsidy, or even had there been generous support by local authorities, were principally these:

(1) Rescuing the repertory movement from the bondage of weekly repertory in deteriorating conditions, and putting it in the position to become the Regional Theatre it is now.

(2) Stabilising Young People's Theatre and Theatre-in-Education.

(3) Nourishing the rapid growth of the Alternative Theatre.

(4) Originating a series of new drama and training schemes for helping individual artists.

(5) Reviving touring.

(6) Re-housing theatres (as part of the Council's overall Housing the Arts scheme, which provided about a third of building costs, this achievement is of a different kind but of far reaching consequence).

All these things needed not only the Arts Council's money, but its championship, when there was no other body that really cared sufficiently, and, in the early days at any rate, a host of opposition, stinginess, prejudice and old fashioned philistinism from members of parliament, local authorities, often the press, and sometimes even sections of the theatre itself. The Council was not quite alone; there was the small army of men and women who made up theatre boards, their staffs, and the core of supporters who struggled against local indifference and apathy.

The post war British Theatre and its actors, directors, designers and dramatists, have greatly influenced drama throughout the world, as well as being one of the chief attractions for foreign visitors to England. Without the subsidy provided steadily for thirty years through the Arts Council goodness knows what kind of theatre we would have today. Some theatre certainly; but a meagre and weak one.

The fundamental decision to provide government funds through an independent, autonomous Arts Council, and not directly from the Treasury or through a government department, was the corner stone of success. Freedom from government or ministerial interference or pressure was, and remains, crucial.

Apart from the professional and unbiased advice it has been able to draw upon through its Drama Panel, the Council was determined to preserve the autonomy of the companies it subsidised, without artistic or administrative interference. Local authorities (or perhaps only some individuals) have sometimes wanted to meddle in the way a theatre was being run, or the plays it was putting on: usually with the best of intentions but always worryingly. Had the Council's subsidy not been free of artistic constraints and censorship, it would have been impossible to prevent far more local government interference.

The Council has always had a struggle to persuade the government to provide anything like enough grant-in-aid, and it never does. In the early years this was especially true, and any student of the post-war theatre should read Sir William Emrys Williams' editorials in the Council's annual reports, which are still entertaining as well as instructive. The Council also had to convince sections of the press, the public, and local authorities that public subsidy was both essential and respectable. That this is now generally accepted in principle, and only the amount of subsidy is questioned, is one of the forgotten successes of the Council.

During the early years there was a feeling, shared I believe by many theatres, that we were all somehow in the same boat, facing common difficulties and trying to solve them together. There was a sense of pioneering. Indeed in the late 1940s and the 50s the Arts Council direct-

ly managed a number of theatres (Bristol Theatre Royal; Salisbury Arts Theatre) and companies (Midland Theatre Company; West Riding Theatre Company) because nobody else was able to do so at the time. Some experiments, like the West Riding Theatre, failed; others, Bristol, Salisbury and the Midland Theatre which was based in Coventry, kept repertory alive in those cities for years until it was possible for trusts to be formed to take the companies over.

The Council also mounted several tours each year which were sent into the theatre-less areas of Wales and England playing mostly one or two night stands in Miners' Welfare Halls, and school or village halls. This was a direct continuation of the tours which had been sent out by C.E.M.A. during the war. It was very much a transitional measure, and the number and spread of these tours was gradually reduced until they were finally stopped in 1960. They were all of a notably high standard, in spite of the difficulties under which they operated. Twelve years or so later some regional theatres in their new buildings began to send out their own tours to the surrounding theatre-less areas, but usually on a smaller scale and geared rather to young people, or experimental work, than the plays of the Arts Council tours.

The National Theatre as an idea, and the Royal Shakespeare Company as a going concern, existed long before the Arts Council was invented, and although both are now supported by the Council it is conceivable that if the Council had not been set up these two companies, or at least one of them, might have been subsidised directly by the State. This essay will not, therefore, refer to the Arts Council's involvement with these companies; but what they stand for, the salaries they pay, the plays they do, the standards of performance and behaviour they set, and particularly the subsidy they need, all bear upon the rest of the profession. At the same time the National Theatre and R.S.C. would find life more difficult were there not a substantial and effective regional and alternative theatre substructure (or superstructure? Whether the National and R.S.C. are the apex of the theatrical pyramid, or its firm base, is simply a point of view!).

The Old Vic, before the formation of the National Theatre Company and its occupation of the Old Vic Theatre, might be considered in the same light. With its history, achievement and prestige it would not have been surprising had it been given state subsidy direct. The English Stage Company at the Royal Court Theatre and the Mermaid Theatre are another matter: I am certain the same would not have been their case, and that the Arts Council was essential for their survival. (Even so neither would have been able to keep going but for the money they

earned through the exploitation of their successes). The argument in this essay referring to the regional theatres therefore applies equally, I think, to the supported companies in London, other than the national companies.

It is a matter of opinion where the mainspring of the British theatre lies - the West End, the great national companies, the regional theatre, or perhaps even the alternative theatre. I suggest the regional theatre - the repertory movement - because it seems to me not only the backbone of the theatre, and where artists grow, but it was with the development of this movement that the British theatre reached maturity, ceasing to be primarily a source of commercial entertainment. This was so admirably described by Sir Barry Jackson, when defining his policy for the Birmingham Repertory Theatre, which he said was '. . . to serve an art instead of making that art serve a commercial purpose'. It is this principle that seems to me the bed rock of the theatre, and is what the Council's drama policy has tried to foster and advance.

It follows that I therefore believe that the Council's greatest contribution to drama in its first thirty years has been the reinforcing, develop-

Table 4

Repertory and Regional Companies in Britain 1952-1978

	1952	1978
Total	151	72
Resident Companies	108	56
Touring or Seasonal Companies	43	16
Of the Resident Companies		
Weekly	92	2
Fortnightly	11	9
3 weekly (or occasionally longer)	4	24
4 weekly (or occasionally longer)	1	15
Repertoire	0	6
Of the total		
Non-profit distributing	40	62
Commercial	111	10
Subsidised by the Arts Council	18	55

ment and eventual transformation of the repertory movement. Table *4* gives an overall picture of the changes between 1952, when I joined the Council's Drama Department, and the present day. Of the 151 repertory companies in 1952, 108 were resident companies and perhaps 60 of those might have been called established, operating steadily throughout the year. 92 of them were weekly reps, and probably 50 of them played twice nightly; some were even twice weekly! There were about 100 commercial repertory companies, of which 14 were run by Frank H. Fortescue and 10 by Harry Hanson. The situation is now completely different; the totals are roughly halved.

That standards are higher, and conditions for the actors much better, can hardly be doubted. Weekly rep was described at the time as a pernicious treadmill, and twice-nightly was almost twice as awful; physically and mentally exhausting for the actors, the director (producer, he was called then), designer and stage management. Theatre visitors from abroad were amazed that putting on a play in a week, week after week, was even possible, while the public had no conception of what it involved for the artists. Of necessity they were usually a small team; no lighting designers, sound consultants, production managers and so on. What was done, and the way in which it was done, was sometimes pretty rough, and often very poor indeed. Nevertheless in many theatres with a weekly change of play the quality of the work was often surprisingly high. In the years immediately after the war when people began to get about more easily, and television hardly existed, audiences were good, and many theatres had most of the house sold out in advance to permanent seat holders. However this comfortable state of affairs gradually died away, and financial difficulties began to arise.

Although at this time, the early 1950s, the Council supported a few weekly repertory companies it was reluctant to do so because it considered that a fortnight's rehearsal was the least that was needed if standards were to be raised. When new companies started up a pattern of fortnightly repertory was encouraged and to some this seemed a luxurious feather bedding by the Council. On the whole, fortnightly standards were noticeably better, but the managers of many weekly companies, whilst accepting the desirability of fortnightly repertory doubted whether their public would stand for such a change, and believed that audiences would simply be halved and thus they would be unable to sustain a two-week run. Over the years all sorts of attempts were made to overcome this problem; one was for regular or occasional exchanges between companies. On the whole this was not a success unless both parts of the exchange were under the same management. Although

several interchanges lasted for a number of years and provided some relief from weekly rehearsals and production, they broke down eventually for a variety of reasons - they were tiring for the artists; they introduced an added complication in play choice; audiences tended to prefer their own company and were lukewarm towards the visitors; managements or their boards became suspicious of the other half of the partnership and imagined they were somehow getting away with something. A grid of interchanging companies was talked about and investigated, but finally came to nothing. Another device was special subsidy to employ a second director and an enlarged company, so that the principals at any rate could be given a fortnight's rehearsal even though there still had to be a weekly change of play. This really did help, and paved the way for many companies to change from weekly to fortnightly playing.

During the 1950s television was becoming widely available, and artists who once had few alternatives to repertory became less willing to work for very little pay under the bad old conditions: and whilst television was giving more work to artists it was also giving an alternative entertainment to repertory audiences, who became less inclined to support skimpy productions in uncomfortable buildings.

Gradually, from the late 1950's one company after another began to take the plunge from weekly to fortnightly, persuaded by extra subsidy, or because their board saw the certain death of the company unless something drastic was done. To their surprise, instead of audiences becoming halved by being spread over two weeks, attendances increased. Once begun, this process was extended, and with financial encouragement from the Arts Council, companies that had been fortnightly advanced to three weekly, and so on. A few experimented with true repertory, or forms of repertoire; but in some towns the public seemed confused and incapable of finding out when the play they wanted to see was being performed; in other theatres the extra costs out-weighed the artistic advantages and the company simply could not afford true repertory. The added flexibility and financial advantages of being able to reduce the number of performances of flops, and increase those of the hits, could not be exploited in the compressed conditions and time scale of a regional theatre; today only half a dozen maintain some form of repertoire system. Otherwise the regional theatres must follow the old pattern graphically described by Sir Barry Jackson when he said that he had 'to take off his successes to make way for his failures'. But with a programme advertised weeks or months before, seats already sold, and furniture, etc. ordered for hire, there isn't much flexibility. One or two theatres tried to guess how long each play might stand, and pre-selected

a pattern varying the runs from perhaps two to five weeks; but if the guesses were too far out the result proved worse than a steady rhythm. Latterly this is being tried again and with greater, if still limited, success.

Longer rehearsal and playing time reduced the pressure, and standards improved. At the same time, that is from the early 1960's, the Arts Council was developing its training schemes, so that not only was there more time, but often more people to do the work.

Managements now needed to choose only half the number of plays. On the one hand they could drop the really weak pot boilers and revivals of old successes, building programmes that were more consistent and attractive. On the other hand a kind of caution crept in, and an unfamiliar play that might have been risked, because it was needed to make up sheer numbers, was now too uncertain to chance for a fortnight. There was a natural need to play slightly safe for a time.

The repertory audience also changed. It had tended to be mostly middle-aged to elderly, and mostly women, although the more enterprising companies which were not doing run-of-the-mill programmes attracted a wider cross-section of the public and a younger audience. During the last ten or fifteen years audiences generally have become much younger, responding to the theatre's growing range of entertainment and service. Even in the theatres which are still old buildings, and of course especially in the new ones, the atmosphere is no longer the dowdy image that repertory once suggested, and too often was.

As the growth of television gave more employment for actors it became more difficult for regional theatres to engage the artists they wanted. In spite of high unemployment in the theatre one knows of directors trying twenty or thirty actors before finding one free or willing to accept a particular engagement, and it is virtually impossible nowadays to hold together a permanent regional company. This has altered the character of repertory companies, and made them less familiar and friendly to their public, which fifteen or more years ago would have found the bulk of the artists staying throughout the season, some remaining for the following one, and a few staying for several years, so that there built up almost a family bond between the regular audience and the players. The inevitable limitations of repertory casting were compensated for by the teamwork of the company, and there is no doubt that a large proportion of every repertory audience liked seeing their favourite actors in a wide range of parts. Members of a company living in the town for several years played an important extra-theatrical role simply by being resident in the community. Of course this relationship has not gone completely, but a permanent company in the form that was

normal at the end of the 1940's and in the 1950's is almost unheard of now in a regional theatre. The longer runs, the coming and going of actors, the alternative entertainment of television, broke or altered the pattern of permanent bookings and regular theatre going. Far fewer regional theatre supporters today would claim never to have missed a show, but in compensation theatres have drawn in large numbers of new, casual playgoers. Each production has to be sold more individually, and publicity and marketing officers with a more sophisticated approach than was needed before are found in most theatres now.

It was always recognised as essential to reach new and younger audiences. Although the Council, in about 1950, started what was then called Transport Subsidy, the repertory theatres were constantly devising concessions to attract bigger and younger audiences. Transport Subsidy had the added purpose of helping people who lived in theatreless areas to visit their nearby repertory theatre. In outline the Arts Council contributed, reasonably generously, towards the fares of parties of eight or more going to the theatre. This scheme had the added virtue from the theatres' point of view of not being a device for them to give money away, but of the Council's subsidy quadrupling itself in the box office. As this caught on, the funds became so much in demand that limitations had to be placed on its use. Much later the whole scheme was handed over to the Regional Arts Associations as they became established. It is still popular and important part of most theatres' policy, with well over a quarter of a million people using the various Regional Arts Association schemes each year, and the numbers increasing steadily.

It can of course be misleading to generalise in talking about the theatre, because no two are alike and sixty or so certainly aren't. It is over simplifying, therefore, to be dogmatic about what exactly was the Arts Council's contribution to the repertory movement, but without the Council's money, persuasion, and advice, a very large proportion of the repertory theatres would have gone the way of variety houses and most touring theatres - that is, demolished or converted to other use without replacement.

The loss of a great number of theatres throughout the country, some destroyed by bombing during the war but most through demolition by property developers, and the widespread neglect of those that remained, led to a physical deterioration so serious that many theatre buildings were described as slums, and had the Factories Act applied to them, they would have been closed down. Half the old repertory theatres had been adapted from a variety of buildings; memorial halls, cinemas, chapels, an art gallery, a billiards hall, a court house, an aquarium. This

Thorndike Theatre, Leatherhead, a product of the 'remarkable surge of theatre building'.
Photo: Concrete Quarterly.

did not make for efficiency of operation or comfort for the public.

Shortly after the war one or two local authorities took the plunge and converted buildings into theatres (Canterbury Marlowe; Chesterfield Civic) and even as early as 1949 the Arts Council was spending small sums on the capital improvement of theatres. In 1959 and 1961 it published two reports on Housing the Arts in Great Britain, which surveyed the deteriorating situation, setting out the need for new buildings and extensive renovation of old ones, and making a case for special money to be provided for this purpose. One new theatre had already been built by a local authority (Coventry Belgrade) and a handful of others were actively being planned or talked about. In 1965 the government provided for the first time a grant-in-aid earmarked specifically for implementing the Council's recommendations and developing a 'Housing the Arts' policy. It happened that the theatre was the best placed of the arts to take advantage of this pump-priming money, not least because of the number of schemes that were fairly well advanced. From then onwards there began a remarkable surge of theatre building, on a scale far greater than would have been thought possible a few years earlier.

In March 1958 the Coventry Belgrade was opened - the first professional theatre to be built in Britain since the war, and the first ever in this country out of public money. (It was not however the first new theatre to be built in Britain after the war; that was the Middlesbrough Little Theatre, the base of the amateur movement in that area, which opened in October 1957, having been funded entirely from industrial and private donations.) Since that time however some forty-five completely new, or substantially rebuilt, repertory theatres have been opened, partly with Housing the Arts grants but largely with Local Authority money and through local subscription. The details are set out in Table 5. Even the very old buildings are now well maintained, and in very few is it still prudent to sit in one's overcoat and to know which broken seats to avoid.

The old buildings were of course the workshop of their companies during the day, and so apart from a box office in a cold and draughty foyer, they were not open to their public until half an hour before the performance - and the audience was in turn shooed out as quickly as possible afterwards. In any case there was generally no public space except the auditorium and bars. The new and rebuilt theatres have met the desire to provide substantially improved conditions backstage and front-of-house, and have facilities for a whole range of entertainment and service beyond the play itself, usually throughout the day. With restaurants, bars, club rooms, lunchtime and late night shows, bookstalls, painting, sculpture and photography exhibitions, poetry readings,

Table 5

Completely new buildings for Repertory

Birmingham Repertory Theatre
Bolton Octagon Theatre
Bromley Churchill Theatre
Chester Gateway Theatre
Chichester Festival Theatre
Colchester Mercury Theatre
Coventry Belgrade Theatre
Derby Playhouse
Farnham Redgrave Theatre
Guildford Yvonne Arnaud Theatre
Hornchurch Queens Theatre
Ipswich Wolsey Theatre

Leatherhead Thorndike Theatre
Leicester Haymarket Theatre
Leicester Phoenix Theatre
London - Hampstead Theatre Club
London - National Theatre
London - Shaw Theatre
London - Young Vic
Manchester Forum Theatre
Nottingham Playhouse
Salisbury Playhouse
Sheffield Crucible Theatre
Worcester Swan Theatre

Completely new University Theatres housing Repertory Companies

Exeter Northcott Theatre

Leeds Playhouse
Manchester Contact Theatre

Newcastle upon Tyne University Theatre

Southampton Nuffield Theatre

Buildings converted into Repertory Theatres

Basingstoke Haymarket Theatre

Lancaster Dukes Playhouse
London - Globe Playhouse

London - Mermaid Theatre

Manchester Royal Exchange Theatre
Newbury Watermill Theatre
Scarborough Stephen Joseph Theatre
Stoke on Trent Victoria Theatre

Substantially rebuilt Repertory Theatres

Bristol Theatre Royal
Greenwich Hippodrome
Harrogate Opera House
Liverpool Everyman Theatre

Liverpool Playhouse
Oldham Coliseum
York Theatre Royal

NOTE, 34 of these theatres received capital grants from the Arts Council's Housing the Arts allocation, but this is far from being a complete list of theatres which have been helped by the scheme.

A complete list of theatres built, converted or modernised since the war would total more than 100. There are theatres like the Reading Hexagon which usually 'buy in' product; others like the Billingham Forum which have housed a resident company for a time. There are many Arts Centre theatres such as Harlow Playhouse or the Brighton Gardner Centre which present a mixed programme, and many small theatres for the Alternative Theatre such as the Almost Free, the Half Moon, or the Bush. Many of the theatres listed above have Studio Theatres attached to them.

films, informal music and full scale concerts, the buildings have become much more than simply playhouses, and in a society which will have much more leisure time they have the potential to be centres of recreation and refreshment in the fullest sense.

The trouble is that they are costing more to run than anybody had estimated. This is not just the effect of inflation, but the cost of overheads for much more sophisticated buildings, far more staff and the need for more highly qualified technicians, demands for higher wage rates and better but more expensive working conditions. On top of all this depreciation and maintainance, and the replacement of furnishings and equipment, is enormously costly. The financial expansiveness of the sixties that made the new buildings possible has been swamped by the inflation of the seventies, so that sufficient revenue to operate the new theatres in the style and scale for which they were planned has not been provided by the Government through the Arts Council, nor through the Local Authorities, and it is much more than can be earned through the box office.

Although our new theatres are playing to many more people than the old ones did, there is already a danger that the people who wish to go often to the theatre are having to ration the number of their visits. So we find that some new theatres are having to be closed for more weeks in the year than they wish or than the old ones they replaced, and most have to do a more restricting programme of plays than they would like, or were able to do in the old building - smaller casts, simpler staging, fewer risks. For all the improvements that have come with the replacement of ramshackle theatres by attractive, comfortable and efficient buildings, the fact remains that - as Appendix 4 demonstrates, the actual programme can be less interesting or ambitious now than it was in the old building.

In short, the expensive plant and the sophisticated equipment, the overall potential of the building, cannot be used to the full, and the capital outlay of public money is not giving back to the community anythink like the return of which it is capable, or for which it was expended. Unhappily this is unlikely to be remedied until government and local authorities realise that for relatively very little more money in national terms the network of fine regional theatres could be giving a better service, and better public value for money than they give already.

If we are to have the number and kind of theatres that we want, giving the improved public service which will be needed increasingly in a society with fewer people in employment, and those working shorter

hours, then more money will have to be found from somewhere.

The Arts Council recognised that subsidy alone could not provide all the support needed if the theatre was not merely to survive but get better. Over the years various schemes were invented, of which the first was the New Drama Scheme, begun in 1952 following an experiment of giving special grants for the production of new plays during the 1951 Festival of Britain. Until then, and in fact for many years afterwards, repertory theatres were unwilling to do new plays because the public stayed away from them. Most relied, in varying proportions, on recent West End releases, revivals, and the classics. The Arts Council's scheme encouraged theatre boards by reducing the financial risk of new plays with guarantees against loss up to an agreed amount. They were small sums, but just enough to mean that a new play might break even. As important, new playwrights were given a little more hope of seeing their work produced, and earning the very modest guaranteed royalty that was built into the scheme. Even so, unless a new play was bought by a West End manager it very often faded away completely, and the scheme was later extended to include the second production of some plays and the revival of neglected plays.

Theatres were also given grants to commission plays or attach a playwright to the company as a resident dramatist to write specially for them. Bursaries and other awards were made to playwrights. Royalty payments were supplemented. All these new writing-for-the-theatre schemes changed, grew, and became more comprehensive over the years to improve conditions for dramatists and encourage companies to do new work. The overall results have been, I think, underestimated and undervalued. Not only was the primary object achieved of encouraging repertory theatres to produce more new plays, but the public has become less frightened by unfamiliar work (television has helped here, of course) and now often positively enjoys it. Playwrights have been given more opportunity than ever before to see their work performed, and they are now receiving a fairer return for their labours. Another consequence is that the commercial West End theatre is no longer the only outlet for new plays, as it once was, and indeed now a considerable proportion of West End shows have originated in regional theatres. The Alternative theatre produces mostly original material and provides an even wider market for new writers also with the Council's support.

Since the early 1960's training (or more accurately, apprenticeship) schemes have been developed for helping new designers, directors, managers and administrators, technicians and stage managers, and most recently, actors. (Some Drama Schools have also been given modest

Table 6

Comparative costs and staff sizes - 1950's to the 1970's

The following companies have all, in different ways, moved from playing in old buildings to new, specially built, theatres. Comparisons cannot be of course made very exactly - for example it is often misleading to compare the numbers of actors employed, as the old permanent companies have now been largely replaced by actors on short-term contracts, so the number of actor working-weeks has increased.

Leatherhead

	Theatre Club	Thorndike
	1952/3	1978/9
Average number of actors	9	8
Average number of other staff	17	40*
Total operating costs	£9,292	£364,000
Total earned income	£7,907	£221,000
Total subsidy from all sources	£500	£133,000
Total attendance	44,350	150,000
Seating capacity	300	526

Salisbury

	Playhouse	Playhouse
	1958	1978
Average number of actors	11	15
Average number of other staff	23	53*
Total operating costs	£23,747	£275,000
Total earned income	£22,666	£179,205
Total subsidy from all sources	£1,200	£95,795
Total attendance	92,000	168,000
Seating Capacity	406	516
		(and 100 in studio)

Colchester

	Repertory Theatre	Mercury
	1952/3	1978/9
Average number of actors	10	10
Average number of other staff	19	41*
Total operating costs	£18,615	£332,881
Total earned income	£17,776	£177,806
Total subsidy from all sources	£181	£150,727
Total attendance	87,555	106,756
Seating capacity	363	499
		(and 80 in Studio)

Sheffield

	Crucible Playhouse	Crucible
	1951/2	1978/9
Average number of actors	18	27 (including studio and Young People's Theatre)
Average number of other staff	20	130
Total operating costs	£24,950	£785,138
Total earned income	£28,100	£314,294
Total subsidy from all sources	Nil.	£423,891
Total attendance	141,251	227,925
Seating capacity	527	1,000 (and 240 in studio)

* Figures for Leatherhead, Salisbury and Colchester, exclude bar and catering staff.

Table 6 Continued

Bristol			Old Vic 1963/64		Old Vic 1978/79	
Average number of actors	T.R.	(43)	18		(43)	22
(No. of weeks in brackets)	L.T.	(32)	10		(28)	9
	N.V.				(30)	7
Average number of other staff (i)			58			112
Total operating costs			£64,759			£681,554
Total earned income			£51,486			£310,385
Total subsidy from all sources			£16,500			£374,500
						(sponsorship 8,466)
Total attendance	T.R.	119,172)			144,305)	
	L.T.	62,490)	181,662		46,420)	210,190
	N.V.	-)			19,465)	
Seating capacity	T.R.	681)			658)	
	L.T.	421)	1,102		360)	1,163
	N.V.	-)			145)	

The Bristol company has not simply replaced an old building with a new one, but now works in a very old theatre modernised and enlarged. There is no point in comparing the present situation to the early fifties as the Trust was not created as an independent body until 1963. The first figures relate to the Theatre Royal and the Little Theatre; the 1978/9 figures include the rebuilt New Vic.

help to ensure their continuence). Each of these schemes operates in a different way, but at some stage they all depend upon the active help and co-operation of the regional theatres and their staffs: the 'trainees' are seconded to theatres and are given practical, rather than theoretical, training. There is no doubt that without these schemes a great number of highly talented men and women would have found it more difficult, sometimes impossible, to gain their initial toe-hold in the theatre, which would be much the poorer without them. More recently opportunities have been created for more experienced professionals, for example Associate Directors.

When the independent television companies were spending some money on training schemes again it was regional theatres that did the training, and in return had the benefit of the extra helping hand. But on the whole the B.B.C., I.T.V., and the commercial theatre, all of which rely very largely on people who are already trained and experienced professionals, in whatever their sphere may be, have done very little to train new people or encourage fresh talent, except for their own immediate needs.

In fostering higher standards and bringing in fresh blood, the Council deliberately encouraged theatres to employ more people. The old

repertory theatres had been run with a minimum of staff performing a wide range of tasks, and working absurdly long hours. The considerably increased staffs now on most theatres' books are naturally adding to the soaring costs of running any theatre. (See Table 6).

It might seem that the Arts Council, made a rod for its own back and led theatres down the primrose path. But the theatre really could not have maintained its position, let alone improved, on the pre-war and early post-war basis of relying on enough people being willing to put up with little pay and uncertain expectations. It was essential to find, train, and keep in the theatre, new talent.

Rather surprisingly it was not until 1966 that the Council first provided subsidy specifically for companies performing for children and young people. Most repertory companies did a certain amount of work for children, usually special matinees or performances for school parties, and of course the pantomime or Christmas show. Their attitude towards this work varied between those which saw it simply as a way of earning a little more income, to a few where service for schools was an integral and important part of their policy. This did not get additional subsidy from the Arts Council but was accepted and encouraged as part of the companies' overall programme. Perhaps it is not surprising that the theatres' attitude reflected that of their local Education Authority, and the most indifferent theatres were nothing like as off-hand as some Education Officers and their committees.

If life was difficult for the repertory theatres it was desperate for the specialised children's companies. Takings, or fees, were pitifully small, and so, therefore, were the salaries of everybody connected with them, and the whole level of work was somewhat makeshift.

In 1965 the Council set up a Committee of Enquiry to look into the provision of theatre for children and young people; by the time the Enquiry's report was completed the following year, it was clear that some of the few existing companies would go out of business unless they had immediate help. Although the Council was not given any extra funds, it made available some of its reserve as first aid for these companies. Eventually the Department of Education and Science agreed that it would be proper for the Arts Council to include funds for young people's theatres in its budget for 1967/78. Since then this work, and Theatre-in-Education (T.I.E.) began to show - some critics think too quickly. Now, through regional theatres and specialist companies there are about 50 T.I.E. or young people's theatre units. A few companies probably took up the idea somewhat superficially, as a way of earning more subsidy, without either sufficient knowledge or commitment

to what was really needed; and here again education authorities differed a good deal in their financial and practical response to what they were being offered. The quality of work was variable, from the poor to the excellent, from soft mush to hard politics. Naturally there is a division between those who see its purpose as preparing audiences of the future - entertaining children, in fact; and others who believe that this is wrong and see it as a medium for teaching. It is here that sometimes what is being taught is questionable. There is no doubt that young people's theatre and theatre-in-education has opened a window to countless young people who would otherwise never have experienced drama. For the few who remain apathetic or put off by what they have seen, a much greater number have been moved towards a new awareness of drama and life, and if a fair proportion of them become confirmed theatre-goers this will be a bonus.

Nevertheless, still the worst served are children of under thirteen (experience shows that most children over that age are capable of understanding and enjoying any play) for whom too little drama of high quality is available. They are not ready for the standard repertoire, and thus the regional theatres seldom cater for them. Very few companies are geared to work exclusively for small children, and there is precious little financ-

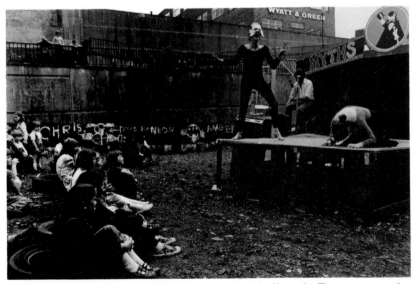

Second City, Birmingham's touring community theatre, part of the Alternative Theatre movement that 'grew and spread itself across the country'.

ial reward for playwrights or artists who are willing to work in this highly specialised field.

An even more rapid growth has been in the Alternative Theatre - which in recent years has sometimes been called Fringe, Experimental, Underground or Community Theatre. An alternative theatre has always existed in one form or another; before and after the war as club theatres sought to avoid the hand of the Lord Chamberlain, for example. The Arts Council aided some of the small theatres and theatre companies at various times, and in the Report of the Theatre Enquiry in 1970 the hope was expressed that this movement, which had until then been fairly small would not confine itself to London, as it rather had done in the past. Following that in the early 1970's, the whole movement grew and spread across the country in an extraordinary germination of ideas, of talents - and some mediocrity. Within a few years the movement embraced a very large number of artists, many of whom were dedicated solely to this kind of theatrical life, while perhaps an equal number moved freely between the alternative and the conventional theatre. By 1978 there were 111 of these groups, 63 of them based in London, of which 54 toured quite extensively; 48 were regionally based, 43 of them also touring. Between them all they regularly used more than 200 small 'venues' throughout the country.

That growth was certainly not created by the Council, but the Council responded to it and supported some of it - although a great deal of work was produced without any subsidy at all. Groups were motivated by every conceivable aim - ideological, social, ethnic, political, educational, religious, even simply to entertain. Most were propogandist and had a common purpose in seeking out new audiences, often in untraditional venues, playing to factory workers, the handicapped, children, in the street or in prisons, for Women's Lib or about homosexuals. Essentially it was - is - committed theatre. At the same time some of it was - is - very self indulgent. A few individuals could set themselves up as 'a group' with little or no training or background of theatrical experience, no financial resources, or formal structure, and sometimes they were resentful then of the fact that the Arts Council would not accept that subsidy was theirs by right because of the mere fact of their existence.

It is particularly unsatisfactory to have to generalise about this movement as its components are even more of a mixed bag than the regional theatres. Their standards varied from the excellent to the excruciatingly inept; at their best they justified the most extravagant claims they made about themselves, but at their worst they were a travesty of drama, truth or life. Many remonstrated against qualitative judgements, and a constant problem was the assessment of standards, which fluctuated

amongst those itinerant groups even more than in a building-based company. Shortage of money and personnel often made their administration haphazard or inefficient. And the sheer numbers of applications for insufficient funds made the Council's task extremely difficult and created an understandable, if unhelpful, abrasiveness and suspicion in the groups, especially those to which no subsidy was given. Nevertheless of the 111 groups referred to, 92 have been subsidised at one time or another, 72 of them by the Arts Council, many of these and the others by regional arts associations and local authorities.

Arts Council subsidy was provided on a much less formal basis than to regional theatres; the groups' constitution and government did not need to be so rigid, and they were subsidised without the implication of any long term, or continuing, commitment. Some groups were given a grant for a year's work, others for a single project, or a series of productions. The amounts of money were almost always relatively small and it is a tribute to the tenacity and dedication of so many individuals that so many groups survived the rigours of this situation. Perhaps it was hardly worse than the repertory companies had to bear in the 1950's.

After four or five years a core of groups emerged as, in effect, the Establishment of the Alternative Theatre, and became accepted by the Council as needing, and deserving, the same kind of security as regional theatres, with the expectation that, subject to prior warning, subsidy was likely to be continued from one year to the next. 40 groups are now subsidised on this basis.

For the others it can be no comfort to recognise that in this section of the theatre there has always been - and perhaps always will be - a relatively short life cycle, and although mortality may be high, so is their birth rate. The present groups have filled the place of a crowd of play-producing societies and tiny club theatres, and emergent groups may eventually replace them with a newer alternative, for the further enrichment of drama.

Touring has always been an important feature of the theatre in Great Britain, and from the latter part of the last century and in the early years of this one, theatres were built in almost every fair sized town to take in touring shows. The big cities had several theatres, for touring plays and musicals, variety, seasonal or summer shows, and repertory. Between the wars many of these theatres were converted into cinemas, and others closed as audiences fell away to the picture palaces. By 1970 about 100 had been lost since the beginning of the war, many of them really splendid buildings. They had been either bombed, converted to other uses, or torn down by commercial developers and town planners to

make way for more profitable office blocks or shops. To be sure, some of these lost theatres had become terribly broken down, and were shamefully neglected by their owners. Not enough had been spent on them in the good years, and by the 1960's it was too late to catch up, the owners claiming they hadn't enough money to do what was necessary. This had been the situation of most repertory buildings also. But whereas in their case there was a local board and a resident company with a spirit to keep the place going and to work for a future, the touring and variety theatres were but lodging houses. The policy of many of them was determined by an office in London, the local manager being hardly more than a caretaker. They were commercially owned and expected to show a profit; if they did not they might be disposed of, and were at risk. Variety was pretty well killed off by television anyway. So, from 130 or more touring theatres before the war, the number dropped to about 30 by 1970.

The quality and number of touring productions had also declined, so had audiences. Gradually the big touring circuits of Moss Empires and Howard and Wyndham, and some of the important independent owners, began to offer to lease or sell their theatres to their local authority.

The Arts Council was not subsidising any of these theatre buildings, although in the 1960's fairly small sums were given to a number of 'mixed programme' theatres which were owned by local authorities, towards keeping their doors open and the buildings available to take in tours.

The national subsidised companies, which occasionally toured opera, ballet and drama, decided that they should plan their touring together, to try to avoid clashes and give a better service to the public, and thus do better business themselves. They came together on a formal basis as DALTA, the Dramatic and Lyric Theatres Association.

The problem of the decline and likely collapse of touring was one of the priority considerations of the 1970 Theatre Enquiry, which recommended the absolute necessity of holding on to a paramount circuit of at least a dozen major touring theatres which should be owned or leased by the local authorities. During the last ten years the key theatres have indeed come into public ownership and many of them have been beautifully refurbished and modernised by the municipalities that now care for them, and their technical facilities have been brought up to the requirements of the touring groups. The Theatre Enquiry also recommended the strengthening of DALTA and other secondary touring measures. The Arts Council, in accepting the recommendations with which it was concerned, went further by setting up a completely new

department to organise, coordinate and increase touring, the nucleus of which was the DALTA staff. The Touring Department's allocation of money has rapidly increased, and in its relatively short existence it has transformed touring from a neglected, casual and uncertain business into a regular provision of excellent companies which give a strong and exciting core to the programme of the major touring theatres.

This has been taken a step further by the extended seasons of five weeks or so by the Royal Shakespeare Company at Newcastle upon Tyne, and the establishment of a second English National Opera Company at Leeds, which are further steps in increasing the accessibility of national companies.

Here then, the Arts Council with essential and substantial local authority support, has saved the touring circuit, and as in the other fields, not simply by the provision of money, but with persuasion and professional knowledge. The problems of touring on its several scales have not yet been wholly solved, and there will constantly be the need to persuade companies to go out on tour; but at least now there seems a likelihood of success.

Because of the dearth of good commercial productions and increasing difficulty of finding enough financial backing for them, the Theatre Investment Fund was proposed by the Theatre Enquiry in 1970, although it was not finally in operation until 1976. Its primary function was defined as being to encourage and assist managements to increase the production of new plays of interest, and revivals of quality, and cause them to tour as widely as possible. The fund was established with initial capital from the Arts Council (£100,000) and private sources (£150,000). It does not offer subsidy, but investment; if a commercial show were to lose money the T.I.F. investment would be lost with that of the other backers; but if the show were profitable T.I.F. would take its share of the profit, and thus it was hoped that the fund would be to some extent self regenerating. It was a novel idea, but has not been working long enough to draw conclusions about the influence it may have on commercial theatre in London and on tour. It is outside the scope of this essay, but its creation stems from the Arts Council, and its eventual achievement may be out of all proportion to the money put into it.

Others could write an essay about the things the Arts Council failed to do, and should have attempted, during this same period. For my part, I believe that the decisions were more often right than wrong. 'Raise or Spread' was not simply a debating point, but a real choice that had to be made in the early years and remains a live issue even for today. Raising the standards was given priority, and now those higher standards

have been spread and drama of quality is more accessible to more people than ever in the past. I feel privileged to have been associated with this achievement of the Arts Council.

N. V. Linklater C.B.E.

worked as actor and administrator in the theatre and was, during the second world war, in the Navy, and afterwards was concerned with the distribution of documentary films. He worked from 1948 to 1952 as Assistant Regional Director in Nottingham; in 1952 he became Assistant and later Deputy Drama Director at the Arts Council, and from 1970 to 1977 served as Drama Director to the Council. He is now a member of Southern Arts General Council and Executive Committee, is on several theatre and other Boards, and reads and paints whenever he can.

REFLECTIONS ON AN ORCHESTRAL THEME FOR LONDON

John Denison

Shortly after my appointment in 1948 as Music Director, Arts Council of Great Britain, I was introduced to the famous Dutch musician Edward van Beinum, conductor of the Concertgebouw Orchestra in Amsterdam, and at that time, like his successor Bernard Haitink, also principal conductor of the London Philharmonic Orchestra. During this introduction he was given an explanation of my job and responsibilities at the Arts Council. No sooner had he grasped that it was mainly concerned with subsidies than wagging his finger at me he said in a lighthearted way, 'It is not enough and it never will be'. In the context of 1948 conditions easily understandable but it was not until a good many years later that I realised how much truth there was in that aphoristic prophecy. Is it in fact the germ of every artist's views on patronage?

In those days the Arts Council enshrined its philosophy and guiding principles in the brave and idealistic closing words of John Maynard Keynes's famous broadcast at the time of the Council's birth:

'No one can yet say where the tides of the times will carry our new-found ship. The purpose of the Arts Council of Great Britain is to create an environment to breed a spirit, to cultivate an opinion, to offer a stimulus to such purposes that the artist and the public can each sustain and live on the other in that union which has occasionally existed in the past at the great ages of a communal civilised life'.

He might also have had in mind the dictum of John Dryden, 'Art makes mighty things from small beginnings grow'. The first Arts Council grants from the Treasury were certainly not large and while there is always a risk of making mistakes at the beginning of a great experiment, ours were not, indeed with so little to spend, could not be, expensive ones. A comparison of resources in 1948 and 1978, even when allowing fully for inflation and expansion can only nowadays provoke with hindsight an indulgent smile - an aside, 'how quaint' - akin

The Philharmonia Orchestra in concert at Wembley Conference Centre, the first to be supported by 'the now familiar London Orchestral Concerts Board' at this venue.

perhaps to remarking on the difference between the Poet Laureate's traditional salary of £40 per annum and the 1978 salary of, say, a stage-hand at the Royal Opera House on considerably more than £100 per week. Was it really such a bad thing - at least for those of us working for the Council in those days - that the lesson of thrift had to be learnt as children first have to learn how to spend their pocket money care-fully?

Let us recall the immediate post-war music scene in London at the time of the Arts Council's birth.

The London Philharmonic Orchestra was already, in economic terms, enjoying privileged status as a result of the generous policy of the London County Council (predecessor of the Greater London Council), to support a contract orchestra with salaried players. It had, through the upheavals of the Second World War and the absence of its founder Sir Thomas Beecham in the United States, become a players' coopera-tive organisation. At this time it had been designated by the London County Council to become the 'resident' orchestra at their new and as yet unbuilt concert hall on the South Bank. This policy was abandoned by the London County Council, shortly before the opening of the new

hall, in favour of a systematised share-out, on a piece work basis, among several orchestras who were to play regularly in the new Hall. Through the coincidence of many influences not least the post-war boom of the recording industry (which was concentrated in London) and the reappearance in London of Sir Thomas Beecham, two new "private enterprise" orchestras, numbering many of the capital's best players, appeared suddenly - really simultaneously - like brilliant meteors, on the London orchestral scene. The Philharmonia Orchestra was created by the recording entrepreneur Mr. Walter Legge and the Royal Philharmonic Orchestra by Sir Thomas Beecham who had obtained a licence to use the title from the venerable concert - giving society of that name. Neither of these two orchestras asked for or received subsidies at their inception. With the London Philharmonic Orchestra and the old-established London Symphony Orchestra, London had become, overnight, the arena and base for four full and independent orchestras. It continued also to be the home of the B.B.C. Symphony Orchestra.

After Sir Thomas Beecham's death and Mr. Legge's "disbandment" of the Philharmonia Orchestra both the Royal Philharmonic and Philharmonia Orchestras reformed as cooperative enterprises on the same basis as the London Philharmonic and London Symphony Orchestras.

If as is sometimes suggested, the four London orchestras have done little more than "survive", one must observe that while group survival is a natural enough endeavour, it is, among orchestral musicians, a remarkable and significant achievement. Generally speaking, they do not wish to become involved in the responsibilities of management or the hazards of the entrepreneur. In more recent times, especially in London, the pattern of cooperative organisation which originally was adopted out of necessity, is now regarded as wholly desirable. Cooperative responsibility gives them in some respects 'employer' status and although collective decision-taking can still be a clumsy and tedious business, it has worked fairly well in these orchestras.

There is today a much greater desire among players to participate in the shaping of their own musical lifestyle and that of the orchestra to which they belong, than hitherto, and while a fair proportion of string players prefer mixed employment to a fulltime orchestral contract, there are many who can accept an orchestral existence provided it is leavened with other activities.

Looking back, one wonders whether it would have been possible in its pioneering days, more than thirty years ago, for the Arts Council or indeed any other grant-giving body to have backed a project creating one orchestra of world class, always assuming that with the right people

in charge, an acceptable formula could have been devised for artistic control and administrative methods. How much and in what way would such a project have changed the course of London's concert life over the intervening years? Would it have survived the brilliant personal successes of, say, Sir Thomas Beecham with his Royal Philharmonic or Dr. Klemperer with the Philharmonia Orchestra in the 1950's and 1960's? The capacity of metropolitan London seems to be too great to contain its manifold orchestral aspirations and appetite through creation, by authority - "the establishment" - of one single orchestra on a wholly privileged basis vis-a-vis the continuing and necessary existence of other orchestras who have always had plenty to do in London's concert life.

The Arts Council and other relevant authorities have pondered hard and long as to whether or not a superb orchestra can be created in London - as a chosen instrument of national and musical prestige - and then supported with resources which would permit conditions of work comparable to those of the Berlin Philharmonic or Concertgebouw Orchestras. The Council, over the years, has sought and taken much advice including that of Lord Goodman's Committee who reported in 1964/5. That body was not alone in concluding that no viable proposals could be recommended to achieve such a goal. Although advocating the status quo, its consequential proposals were all implemented through the establishment of the now familiar London Orchestral Concerts Board. This is still the operative body supervising the present arrangements - on behalf of the Arts Council and Greater London Council - to subsidise the four orchestras and other major London orchestral promoting societies. Those proposals have at least stood the test of time, for nearly fifteen years, and no one could claim that musical standards or working conditions in the orchestras have deteriorated over that period. On the contrary, important improvements in working conditions have been made and a measure of general consolidation has been achieved within the framework of existing conditions.

More recently another enquiry conducted by Sir Frank Figgures reported very fully on the current problems. Sir Frank was unable within his narrow terms of reference to suggest, 'a more rational and coordinated policy for the organisation and support of the orchestral life of London'. The Chairman of the London Orchestral Concerts Board states however in the most recent Annual Report of that body that, 'The enquiry focused attention once again on the need for a London orchestra comparable to those found in Berlin, Vienna, Cleveland and Chicago and with sufficient resources to provide more enterprising

A Performance at Royal Festival Hall, London. A concert hall that 'works'.
Photo: Greater London Council.

programmes'. He adds that the Arts Council is yet again to study this problem. Can it be that, with vastly increased resources, some million pound plan for such an orchestra is even now on the drawing board?

A world class orchestra cannot, for sure, be created without finance on a most generous scale but I have an uncomfortable feeling that it cannot be attained through money, optimum working conditions and wise policy-making *alone*. The B.B.C. Symphony Orchestra and other orchestras in various parts of the world already enjoy in great measure all of these things. What is lacking? There is perhaps more than a grain of truth in the cynical band room jibe, which claims that an orchestra will play as badly as its conductor permits and, conversely, that a "great" conductor can make an ordinary orchestra sound first class. Nor is it really encouraging to look back to the days when the N.B.C. provided enormous resources for Toscanini to create the best possible orchestra in New York. Under his personal inspiration and guidance, its achievements would indeed be "legendary" were it not that its recordings are convincing evidence of its magnificent qualities. It did not survive however, as an institution in its own right, after Toscanini's retirement.

Many reports on the London orchestral scene fail to mention, yet

alone appraise, the role of the Royal Festival Hall. Not merely is it a successful building, but its situation, facilities and management policy have had a profound effect on the multifarious aspects of London's concert life for nearly thirty years. The motives and resolve of the London County Council in pushing through this project so soon after the Second World War against a good deal of political opposition cannot be overpraised. It remains a permanent monument also to the post-war spirit which imbued the 1951 Festival of Britain. No need in this context to review the building from an architectural or acoustical standpoint but the simple fact remains that as a concert hall it 'works'.

Does it not serve uniquely well the purpose for which it was built? It is not only a formal concert auditorium with a capacity of 3,000 but also a modern all-the-year-round version of the 18th century Pleasure Gardens at Ranelagh and Vauxhall. I do not know of any other building of its kind in the world which serves its community and visitors quite so successfully. International musicians who do not already know music on the South Bank invariably remark upon its particular and welcoming atmosphere and above all that it seems to attract a seemingly unlimited public of "ordinary people" attending nightly to listen with a fair knowledge and sense of discrimination to "classical" music performed invariably at first class professional standards. A poorly attended concert of well-known music can happen for a whole variety of reasons, ranging from perhaps a conductor unknown to the London public or indeed the weather. Some writers like to suggest that this indicates that the concert-going public is at last surfeited with the well-known repertoire of 18th and 19th century masterpieces. The statistics however prove otherwise. (See Table 7 below).

Table 7

Attendance figures for four seasons' concerts given by the four London orchestras in the Royal Festival Hall.

1975/6	357,923
1976/7	365,349
1977/8	376,983
1978/9	301,237

The "conservative" and "unenterprising" character of the programmes presented by these four orchestras in the Royal Festival Hall throughout the eight month concert season has been much criticised in the Press for several years. Most of the criticism emanates in fact from a few professional journalists and music critics.

For the most part this emphasises the repetitive aspects of the orchestral programmes offered to concert-goers, inferring frequently that the managements are too lazy, timid, or ignorant to include more challenging and significant examples of contemporary composition. It is, however, conceded sometimes that since the orchestras have to manage their affairs on the tightest of annual budgets there is no money to spare for the extra rehearsals required to prepare these difficult works or to compensate for the inevitably large number of empty seats which are, alas, a concomitant to such programmes.

No one would wish to suggest that concert programmes should be exclusively made up of the incomparable great and well-loved masterpieces which continue to hold first place in the minds of performers as well as listeners. Why indeed should there not be a sort of National Gallery in music? Are there not cogent and justifiable reasons why these works have for so many years held their central and key position in the musical repertory? They have, as in their dramatic, graphic or literary counterparts, a quality and profundity which enables the great majority of listeners, not merely to enjoy because familiar, but, through study and greater knowledge, to participate in an uplifting, inspiring and increasingly rewarding experience.

There is no doubt that the existing complex and multiform concert scene in London has come about through the interplay of many independent and varied spheres of employment and patronage. Our own national predilections too are towards a variegated pattern of many little specialised groups and societies to accommodate as many worthy causes and projects of this or that music as may be feasible. It makes for a remarkable variety, a richness of experience, though it cannot be denied that in certain aspects of all this busy music-making the stigma of 'second rate standards' is sometimes not unfair.

Music nowadays is so easily accessible through radio and recordings that thanks to the B.B.C. and the happily much enlarged and enlightened catalogues of recording companies, today's and yesterday's experiments by composers can be heard and studied far more easily and effectively than ever before. Recordings in particular, are surely the best and most convenient method of familiarising oneself with music couched in a difficult and complex idiom.

The huge variety and sheer volume of London's concert life offer unequalled choice to the concert-goer. Consequently most efforts to launch subscription schemes for a series or package of concerts end in failure, so far as London is concerned. The individual concert-goer can indulge his preferences, concert by concert, from an almost inexhaustible list. In 1979, there were only two orchestral societies in London who over the years have weathered the storm of maintaining a steady subscription audience. Neither puts on particularly adventurous programmes but it is noteworthy that the Royal Philharmonic Society, can and does include in each of their annual series of eight concerts, two or three carefully selected first performances of contemporary or little-known near-contemporary works without decimating their box office sales.

In London one thing stands out very clearly as the principal factor governing the public's response to any concert. It is the opportunity to 'assist' - in the French sense, i.e. to be present physically - at a live performance by an artist or artists whose talents are already admired and loved. Through familiarity by radio or record, many an artist who has already beguiled by the ear alone, is able when performing live, to enhance this charisma through the visual senses.

These reflections concern London's concert life during the normal season from September to June each year. What is one to say about that unique, exciting, great, popular festival of Promenade Concerts which fill the remaining months of the year? If their founder, Sir Henry Wood, could survey the vast extensions to his still valid fundamentals of programme planning, he would surely marvel not only at the range of works performed by so many different orchestras, boxing and coxing nightly in kaleidoscopic patterns, but at the eager and enthusiastic reception they receive from thousands of youngsters who foregather in London during this holiday season.

The Proms are no doubt a special case. The 'formula' has been tried at other times of the year without success. Are they the exception which proves the rule elsewhere? The B.B.C. alone in the promotional field has the means to organise and mastermind such an enormous assembly of musical experience. We should never forget to thank them for doing so.

As we enter the 1980's where do we stand in all this bustle of orchestral and concert activity? I say - as anyone fortunate enough to have taken part in the enormous expansion of musical life since 1945 might say - that we stand 'well' in the international league table.

But things are always changing - the 'accepted' must gradually

give way to the innovatory elements in composition and performance. I would prefer to see the goal of a world class orchestra reached gradually through our existing resources. Let the L.O.C.B. increase its support step by step to the more enterprising and successful of the four orchestras - rewarding not only the constantly advocated programmes of new music, but actual standards of performance achieved through entrepreneurial skill in booking the best conductors, solo artists and players. It should resemble a long distance race rather than a sprint. In due course, we could then find ourselves, one day, with an orchestra which in the long run had noticeably outpaced the others. Cries of unfair discrimination would probably be heard for a time, but, wielded judiciously and consistently, I believe that the Board's judgements would ultimately come to be respected and accepted as perceptive and fair.

Finally let us, in spite of grumbling in some quarters of the Press, keep the huge, largely repetitious, but variegated pattern of concert life in London. Its glory lies in the amazingly contrasted programmes and artists performing in so many venues on every day of the year.

John Denison C.B.E.

has had a long and distinguished career in music. He was a chorister at St. George's Chapel Windsor at the age of nine, singing Byrd but preferring Mendelssohn. He abandoned a legal career in favour of playing the french horn in the B.B.C. Symphony, London Philharmonic, City of Birmingham and other orchestras before the war. A distinguished war career followed and in 1946 he turned to music administration, first as Assistant Director of Music for the British Council and, from 1948, Music Director of the Arts Council of Great Britain. In 1965 he became Manager of the Royal Festival Hall and then Director, South Bank Concert Hall. He was Chairman of the Cultural Programme, London Celebrations Committee at the Queen's Jubilee.

THE BUREAUCRAT AND THE ARTIST

Jo Hodgkinson

It is just over thirty years since Parliament approved the setting-up of the Arts Council and 'administration of the arts' as national policy began in earnest. In that short time a good deal has been learned about what to expect when the artist, with his demand to be free, and the organiser, with his rules and regulations, come together and work for the good of an art. If it is true, as has been said, that 'conflict is the essence of drama', then here is drama in the making! In his book *The Way of My World*, the late Ivor Brown, who was a senior officer at C.E.M.A. headquarters from its beginning, says that:

'To work among artists is always to live in a certain atmosphere of storm and strife, since artists are naturally and rightly strong believers in their own ideas and ways of doing things. They are convinced and stubborn at their best, and wayward and too easily jealous at their work. If to the handling of such types is added the apportionment of State grants, the buzz of public criticism is inevitably added to the disputation of the sects'.

Disputation over the apportionment of State grants has been a familiar feature of the administration of the arts from the beginning, and shows no sign of ending. To some extent the trouble began with the policy slogans, 'The Best for the Most', and 'Raise and Spread', both of them understandably taken to mean by artists everywhere that their particular enterprise would be given 'the full treatment'; and they were not slow to point out that by the terms of its Royal Charter the Arts Council was required first to increase the accessability of the arts throughout the Realm and second to raise the standard of performance of those arts. It was no consolation to disgruntled applicants when the Council explained that unless unlimited finance was available, and clearly that had never been the case, these two purposes were in conflict, one with the other. So the dispute continues, with the Council at times being criticised for spending too much of its grant in the regions and at other times for spending too much in London.

On one occasion the protest was made in a most original way. Bernard Miles came to see me to express bitter disappointment with the grant which had been offered for the following year to the Mermaid Theatre; it must be increased or the theatre must close. I explained to him why this could not be done; the Council's policy was now to give preferential treatment only to regional companies, which were desperately in need. He departed, obviously very upset, and half an hour later our caretaker telephoned me. 'Excuse me, sir, you shouldn't have given that table to that gentleman; we need it every day'. When I asked him to explain he said that 'that gentleman' had carried the table downstairs, explaining to the receptionist that I had said he could borrow it because it was just the thing for his next production. I rang the theatre and a voice with a strong West Country accent said 'Mr. Moiles' was out and he was only the carpenter; yes, he had the table but it was a shade too high for the show and 'Mr. Moiles' had told him to saw a bit off each leg. By this time 'the penny had dropped'; 'Bernard, if that table isn't back here in an hour's time I'll . . .' and with a chuckle he was gone. When we next met he was immensely pleased with his gesture of protest. 'Well, I was determined to get *something* out of the Arts Council, whatever happened'.

The conflict implicit in the policy 'Raise and Spread' was to some extent resolved by the decision of the Council to concentrate at first (and while its financial resources were - to say the least - modest) on the needs of those activities in the arts which were of quality and were most advantageously placed to provide the best for the most, for those who could get to them. The days of touring the arts to the people were over, and those from areas newly deprived by this new policy were encouraged by a Transport Subsidy Scheme, and concessions on admission prices, to travel by train or coach to the nearest approved 'centre', where they could enjoy a higher standard of presentation than had been possible in their local town hall, dance hall or school hall. So now it was a case of 'taking the people to the arts'. The one exception to this in drama was the setting-up of a directly managed company based in Coventry (and touring to two other towns in the area) where most of the war-time play-tours of C.E.M.A. had had their first showing. This 'gesture' to a city which was being completely rebuilt led eventually to the opening there of the first new theatre in Britain for many years, ''The Belgrade'', as a home for a resident repertory company.

There were some unexpected reactions to the first approaches made by the Arts Council to the repertory theatres selected for grant-aid. Two of them were in the North West Region, and in one case I invited myself to a management committee meeting, explaining the purpose of my visit

110

and the intentions of the Council. When I had finished there was a brief silence, then the Chairman said, 'Mr. Hodgkinson, we have run this theatre for twenty years without ever having to ask anybody for charity, and we don't intend to start now. But thank you for coming: good evening' - and I was out! In the other case, it wasn't the Council's charity they declined; they feared its interference and I was quite unable to reassure them on this. They both remained independent of 'charity' until the inexorable rise in production and maintenance costs, plus the effect on box office of other and rapidly developing attractions, put the existence of their theatres at risk. But I still remember the sad, regretful look of Sir Barry Jackson, the Founder and Chairman of the Birmingham Repertory Theatre, when I first attended his board meeting as the Arts Council's assessor. It clearly said, 'I'm beaten: I've had to accept charity'. That 'charity' was a first grant of £500. Happily it didn't take long to cheer him up!

But cases like these were exceptions: most companies accepted Arts Council help, modest though it was in those early years, with genuine relief and gratitude. However, for a time at least it could be a delicate situation for the Council's assessor - this stranger at board meetings - requiring good sense and tactfulness on his part, and toleration on that of the members. They had to become accustomed to the idea that here was an 'outsider' who was observing every detail of whatever they were doing and reporting on it to his Council; who could come and go as he pleased but must never be asked to go; who could say what he liked when he liked, but would never *vote*. It always seemed to me that it was their assessor's abstention from voting which finally removed the doubts some of them had about this apparent interference in the day-to-day running of their affairs; and certainly for the assessor it proved - and still does - to be a boon and a blessing, especially when after heated debate he doesn't have to side with any of them.

It is when these adjustments to each and everyone have finally been made that the Arts Council's officer is able to take a useful part in the affairs of the companies to which he has been 'accredited'. He needs to make himself available to everyone, not merely at board meetings where he is in an official position, but with individuals on the Board or on the staff at any time they approach him. It is with the staff that this is of greater importance, because they look to the Council's officer as someone from outside the daily grind, who will understand and look sympathetically at their problems as one professional to another. He is also the one person above all others to whom the staff look for support when they are in difficulty over some detail of artistic policy. The

members of the Board, on the other hand look to him for professional comment on its overall policy in running the company, be it finance, public relations, management or artistic policy - and the greatest of these is finance. For it must not be forgotten that at all times, and especially in the early years, these companies work to a strictly controlled budget in which the contribution from the Arts Council is always less than their own estimate of need - just as the Arts Council's own budget always is. This is a problem which often produces tensions between the Board and the artistic direction, and it is between these two different approaches to policy planning that the Council's assessor must be able to give an opinion without allowing himself to be over-influenced by the special pleading of one side or the other.

This is particularly important when that 'certain atmosphere of storm and strife' - as Ivor Brown called it - develops between the Board members and the staff, because of either depressing results at the box office or a wayward or stubborn attitude being taken on one side or the other; sometimes it can be all of these. Then the Council's assessor must choose the moment when he feels it is necessary and right for him to intervene; he may need only to restore good sense and calm, but at times he may have to play a 'counsel for the defence' role if he is convinced that justice is not being done. I have often had to take this role on behalf of the artistic director, who is most often - and often unfairly - the target for blame when things go wrong. He is seldom his own best advocate in such circumstances because he has been too closely involved in the creative work of his theatre, and has great difficulty in judging the result with an uncommitted, unbiased mind. But there should be no difficulty for the assessor in doing just this; nor in fully appreciating the efforts of the artistic director and his company. This is no time for him to maintain his position of neutrality; he must speak out unhesitatingly on behalf of whoever he is convinced is being unreasonably treated.

This 'whoever' was once, in my experience, the Board itself! It had been decided that a senior actor who had recently joined a well-known Midland company should be appointed as artistic director, and for a few months everything went smoothly. Then it began to be obvious that the wishes of the Board were frequently being ignored by him and that the whole enterprise, including management, was under his control and not the Board's. Two meetings were held at which everyone, myself included, tried in the friendliest way to sort things out with him, but he treated the whole affair off-handedly, saying in effect that he didn't know what all the fuss was about. Private talks with him made no difference, but made it clear that he regarded the Board as a nuisance and everyone

on the staff, including the manager, as subservient to him. Eventually the Chairman called a special meeting of the Board, and gave a fair summary of events and the present situation; he then asked every member to speak in turn and say quite frankly what action each one thought should be taken. They were all in agreement that the artistic director should be dismissed. The Chairman then asked for my opinion - he had insisted on me being present at all these discussions, and had reported them to my colleagues at headquarters. I said that I could see no hope whatever of a change of attitude by the artistic director, that I thought the Board had done everything possible to bring about this change, and that the whole situation had now become intolerable. A vote was taken and the artistic director called in to be informed of the decision. He had nothing to say, and left the meeting immediately, although he later permitted a radically different version to be published, and became something of an artistic martyr[1].

This ambition of some artistic directors, or some general managers, to become 'the cock of the roost' was not uncommon in those days, and I am told it is becoming more common today. I always advised against it, not because I thought that one or the other was wrong for the job, but because I believed that for one person to assume full responsibility for both departments was bound to lead to weakness in one or the other sector. I believe this to be even more likely today when theatres are providing for far more people than just those who come to see the plays; they provide special occasions for juveniles and young people, many of them operate as arts centres, provide space for art exhibitions and concerts; the building is in use day and night and direction and control is becoming more and more complicated.

The most satisfactory system of government for a theatre was always, for me, in those where the artistic directors and the general managers were appointed as equals by the Board of Governors. One such was the Theatre Royal, Bristol: the arrangement worked especially well there, and was shown at its best when planning proposals for the next booking period came before the Board. The artistic director first outlined his suggestions, and there were always more plays on his list than would be needed. He gave a brief survey of each of them - the pros and cons, as it were - but made no specific recommendation of any one of them. The Chairman then asked the general manager for his comments on each play, as a likely box-office success or otherwise, or as to its qualitative value in his public relations department. General discussion then followed, and a final selection made. One great advantage of this procedure was that, if any play failed to attract good audiences, the

post-mortem on it at the next Board meeting was the occasion for everyone sharing the responsibility, not just the staff . . . There was no storm and strife.

The existence of a good working atmosphere in an arts organisation depends a great deal on whether the membership of the Board is constituted so as to ensure a reasonable balance between the varied opinions and attitudes of its members. They are normally recruited from a wide selection of professions - education, business, literature, law, politics and social services - and only rarely are any of them professionally involved in the arts. For most of them, attendance at the meetings of the Board is a welcome, even a fascinating change of scene to which they each bring a detached, objective mind. This is what is needed, especially during discussions on artistic values and artistic policy, when differing personal points of view must somehow be brought together to formulate a policy for the Board. The main concern of all of them must be to ensure the survival of the organisation from year to year, and survival depends on a sound financial policy; they are hardly less concerned also to make sure that the reputation of the company, locally and nationally, remains high. And therein lies the conflict which can lead to the disputation of the sects. There is everything to be said for disputation provided that the composition of the Board membership does not allow one 'sect' to have a dominating position over any other. I was particularly interested to see what would happen when representatives from the local authorities first came on to theatre Boards. Would they have a dominating position? It was obviously a very strange experience for them. 'What a delightful change from Council Committees' one of them said to me. 'And what interesting people. I'm fascinated'. They had the right to vote, of course, because their Council's grant to the theatre is the ratepayer's money, but for a time they reserved their right until they were sure of the line they wanted to take over the problems. When they did vote it was as individuals and not on any 'party line'; the thing which mattered most to them was the right policy for the theatre, and there was many an occasion when they took a different decision from one another.

But the course of the living arts never did run smooth all the time; there is always the possibility of a head-on clash between those most concerned about financial policy and those concerned about artistic policy, usually provoked by a sequence of disappointing results at the box office and frequently culminating in demands for drastic changes in one policy or the other. Then it needs all the skillful diplomacy of the Chairman to reduce tension, smooth down the hurt feelings and frayed

tempers, and being the resolving of differences which must be within the capability of everyone, without harm to personal relationships or to the enterprise which is the over-riding concern of them all.

Two instances of a variation from the usual pattern of Board membership have occurred in my own experience. The Royal Liverpool Philharmonic Society agreed to a proposal from the City Council - which had offered to take over the Philharmonic Hall and accept full responsibility for maintenance and running costs - that a new governing body should be set up consisting of six members of the Council, six of the Society, and a further three independent members to be nominated by the Arts Council. This meant that in the event of serious differences between the Society and the Council these three members would hold the decisive votes. This arrangement continued with success until the recent reorganisation of local government boundaries necessitated changes. This was the first time that the Council had been invited to nominate members with special knowledge and understanding of its affairs to the governing body of an arts organisation; and it has received similar requests in other cases since then.

The other, perhaps more striking instance, is that of the Wyvern Arts Trust, which was established in Swindon as the governing body of the Local Authority's new theatre and arts centre. The constitution provides for the Trust Council to consist of three members of the Local Authority, three "professional theatre administrators" to be appointed as members by the Authority, and one member to be appointed by the Swindon Theatre Guild of amateur societies. Provision was also made for a further five members to be co-opted on to the Council; one such co-option has occurred to date, and this brought a fourth professional theatre administrator on to the Council.

Administration of the arts - particularly of the performing arts - can be an art itself; some would claim it as a fine art; for the Council's administrator is involved not only in the assessment of the financial needs of any company - a comparitively simple task - but in the quality of its work, its value in the world of entertainment, and perhaps most important, in forming his own opinion of those persons in control of the whole enterprise - the Chairman, the members of the Board of governors, the artistic director and the general manager. He has to assess their performance with the same critical sensitivity as he does that of the artists on the stage. It is not easy for him to do this, because at his first meetings with them he will encounter as great a variety of individuals as it is possible to imagine might be found sitting around the same table, each one of them expressing an equally great variety

of views about the arts. Then he must establish his own right relationship with them as individuals and as a group; a relationship which is friendly and sympathetic but which none the less maintains his position as an independent observer.

As he attends the meetings of the Governors of these companies he will be amazed by the different ways in which different meetings are conducted. From a glance at the agendas it would be assumed that each would proceed exactly as any other - but not in the arts! There are too many intangibles wrapped up in those agendas, and the attempt to come to grips with them can be exciting, or dull, or amusing, depending on the manner in which the Chairman conducts the meeting. He may be a very punctilious and precise person, dotting every 'i' and crossing every 't', one who is somewhat impatient of discussion because he has thoroughly 'done his homework' beforehand and decided all the answers. Another may deliver a dissertation on each item as he comes to it - a very good dissertation maybe, but one which leaves little or nothing to be said by anyone else, and if someone does venture to speak the Chairman will listen attentively, say 'Thank you very much' and carry on as though no one had spoken. Such Chairmen are certainly very efficient and time saving: but they leave everyone else feeling rather unneccessary and reluctant to start a discussion. I have always much preferred those meetings at which the Chairman is of a volatile, extrovert temperament, always enjoying a bit of a tussle with his colleagues or the staff, even occasionally 'blowing his top', and while content to allow freedom of discussion he will - at some point not too long delayed - indicate that he's heard enough and say, 'What it all comes down to is this, isn't it', and it is. I have often enjoyed myself more at such meetings than I have afterwards in their theatre. This was especially so on one occasion. The Board meeting, as was usual, was held in the early evening at the Chairman's house, where he was always the charming and gracious host to his colleagues. All was going well until something was said - and I have forgotten what it was - which caused him to turn in great anger upon the poor producer, shouting at the top of his voice - and it was a good voice - and banging on the table. The Board members hung their heads while the storm raged until one of them looked pleading at me to intervene. At the moment there was a knock on the door which was opened by the Chairman's wife who stood there with a carving knife and a sharpening steel in her hands. The Chairman stopped in full spate while the rest of us gazed wonderingly at her. Then she said in the most gentle tone, 'Darling, could you please sharpen this knife for me?' The Chairman answered

equally gently, 'Certainly, my dear' and hurried off to do as he was bid. What was said outside as he sharpened that knife we shall never know, but he returned to us completely calmed and the meeting continued as though nothing had happened. But not one of us doubted that his wife had devised her interruption deliberately so that she could soothe his troubled mind. One member of the Board said to me afterwards, 'For one awful moment I thought he was going to carve poor Lionel into little pieces!'

In the previous chapter N. V. Linklater has described how the Council sought in the early fifties to raise standards by encouraging theatres to move away from 'weekly rep'. The tension in those companies was high, and neither administrator nor actor could be said to function well. Nevertheless as the changes came and the weekly reps began to disappear there were unexpected new conflicts. 'We always come every Thursday' I heard one couple say to a box office manageress 'and now we can only come every other Thursday. It's not right you know'. But the pressure from the Arts Council to make the change continued and its grants were increased to those companies that did so. Then came new problems, because many of the artists who had been drilled in the severe routine of weekly rep found it incredibly difficult to adapt to another whole week of rehearsal time; indeed, one actor was heard to say to his producer, 'If you give Harry another whole week to rehearse in he won't know what to do with it'. There was more than a grain of truth in the remark, and it didn't only apply to Harry.

Thus, it soon became obvious that a scheme for the training of producers, designers, technicians and managers in grant-aided theatres was urgently needed, and the Arts Council agreed to set it up. Discussions took place with the Conference of Repertory Theatres (C.O.R.T.), which was the co-ordinating body for all such grant-aided theatre, with the newly formed Association of British Theatre Technicians and with "Motley", the distinguished firm of stage designers, and it was arranged that these three should offer training facilities which would be partly theoretical and partly practical experience in a repertory theatre. The scheme was explained to the Boards of Governors of all grant-aided theatres and their co-operation asked for, so that any member of their staff who wished to take the appropriate training course be released for a short spell, and also that they would agree from time to time to allow trainees from the courses to work in their theatres. All this was well received and training started, slowly at first but growing steadily in numbers as the talk about them spread. Two new courses were later added, one for stage managers which C.O.R.T.

agreed to arrange and supervise, and one for general managers. The training of actors and actresses did not come into the scheme until much later when short-term post-experience courses were introduced.

Considerable impetus was given to training when the Council's 'Housing the Arts' Fund was established. This was applied, in the first instance, to structural modifications in selected theatre buildings and to improvements and replacements of outdated technical equipment; but as the new theatres came along to replace the old ones, or reappeared in towns which had long been without a theatre, the need for training in every department became vital. The Council then appointed an officer for training to supervise and coordinate all training courses, some of which were now being 'housed' in technical colleges and were later to be included as part of their curriculum though still under the Arts Council's aegis. Training has now become a department of its own within the Council's rapidly extending range of activities, and there can be no question about its value to the living arts or for its continuing necessity to the profession.

There may be some question, however, about the need for the Arts Council to keep this fully grown offspring within its 'family' any longer. Is vocational training the proper business of an institution which is first, and always must be, concerned with the assessment and maintenance of the highest quality in the arts? Would it not be a wise decision to establish training as an independent activity with its own controlling council so that it may develop in its own free way alongside other training bodies? Pruning the vast extent of Arts Council activities of this one section alone could be done with advantage to both, and without any difficulty.

The Council is already greatly concerned about 'the current proliferation of quasi-vocational degree courses' in the arts, which because of the perceived nature of their curricula . . . cannot properly equip the student to work in such areas'. The existence of an independent professional training body with a full scale curriculum would expose these weaknesses, and by the quality of its 'graduates' would discourage the students taking such courses from thinking they were qualified to work in the professsional arts.

NOTES

1 See **The Neville Affair; the Facts** by G. R. Hibbard (Published by the Nottingham Playhouse Action Group, 1967).

Jo Hodgkinson

is one of the best known figures in the post war theatre world. He is also one of the longest serving of all senior Arts Council Officers, having been appointed Drama Director in 1954 and remaining in the post until his retirement in 1970. He thus presided over the Drama Department in its great expansionist periods and has unrivalled experience of the tensions which accompanied the change from commercial to subsidised theatre provision.

STATE SUPPORT FOR THE VISUAL ARTS: SOME PROBLEMS

Robin Campbell

Since the 50's and 60's all the arts in this country have been looking increasingly to national and/or local government for financial support. It is not difficult to see that costs in theatre and concert hall have swollen to a size which makes some form of public subsidy inevitable. It is perhaps less obvious that literature and the visual arts need to be supported as well.

However, before discussing in greater detail the subject of this essay - state support of the visual arts - it may be as well to examine briefly the assumption that the arts cannot still today rely for their rewards on 'the free play of market forces'. Pop concerts, long-running plays, musicals and popular films normally show a profit; a few writers and artists make quite a lot of money. So why interfere with well established mercantile principles?

The answer can be briefly stated, I believe, under two heads: the need for variety and ferment in the arts if they are to evolve as an integral part of our culture; secondly, the often slow acceptance by the general public of work in all the arts which questions existing assumptions and seeks to break new ground. A lively theatre, for example, needs the stimulus of Repertory and Fringe if playwrights, actors and directors are to develop their talents. (A series of plays like 'The Mousetrap' would do little to nourish such development).

It is an observable fact that much of the more 'difficult' art of the earlier part of the twentieth century is now widely appreciated; Matisse and Picasso are examples among a host of others.

If we think of artists as occupying a continuous spectrum with at one end those who are perpetuating traditional skills and at the other those who are questioning the very nature of art and its function, we may expect that talent will emerge at any point along the spectrum; however, the fact is that it is easier for many to appreciate work which

resembles what they have already learned to like. To take an analogy from industry, there can be few successful commercial undertakings in the present climate of rapidly developing technology which do not devote funds to research and development.

Turning now to the visual arts in particular, it must be conceded that it is virtually impossible to assess the degree of success or failure of the forms which public support has taken in this country since the last war. We can never know how things would have developed if methods had been different or if there had been no support at all.

There was however, one area where the Council had a plain duty to both artists and public: the mounting of exhibitions both ancient and modern, foreign and British, for London and the provinces. Without a plentiful supply of temporary exhibitions of original works, art appreciation, art history and art criticism tend to stagnate, even art itself; for most artists find nourishment in the work of their predecessors.

By an historical accident - or by traditional parsimony - neither national nor municipal galleries and museums were able after the last war to devote funds to temporary exhibitions. All their resources were needed for purchasing, display, conservation, cataloguing, building maintenance and other such necessities of permanent collections. Their situation had slightly improved by the late 60's and 70's. But it is still almost impossible for them to keep pace with the rapid rise in the cost of works which museums need or wish to acquire in the face of avid competition from the scores of new museums in the U.S., West Germany and elsewhere and with the disastrous effect of inflation on the art market for institutional buyers.

The mounting of temporary exhibitions of original works (both foreign and British) for London and the regions thus became one of the Council's most important functions in the 50's and 60's and indeed remains so. Unfortunately the cost of mounting exhibitions is still rising steeply, it has probably quintupled in the last ten years, and a substantial proportion of the government grant-in-aid to the Council is spent on this activity. The Council has traditionally regarded the provision of exhibitions as in some ways analogous to the national library service and subsidised it accordingly.

The circulation of study material to regional museums was undertaken by the Victoria and Albert Museum until the controversial decision in 1977 to save money by winding down this unique service.

A recent development in the exhibition field, stemming perhaps from the fabulously succesful Tutankh'amun show at the British Museum, has been for such organisations as the Times Newspapers to

122

mount very large 'blockbuster' shows with the help of professional firms engaged in publicity. Since such exhibitions do not enjoy any state subsidy they are normally expected to show a profit. To achieve this profit vast numbers of paying visitors must be persuaded by sustained and intensive promotion to pass through the turnstiles - visitors who might not otherwise be drawn to an exhibition of the works of, say, Courbet or Millais. They will be tempted to buy souvenir publications, reproductions of works in the show and items such as reproduction jewellery. Stylish installation is of prime importance in such shows. All these factors entail a very substantial outlay of funds for uncertain returns - a bit of a gamble for the promoters - the success of which it is difficult to repeat frequently. Nor should the organisers of exhibitions forget the adage that it is not the number of visitors which make a truly successful exhibition, but the quality of the experience they find there. However priggish this may sound, it is profoundly true.

Table eight gives a general picture of how support is now given by the Arts Council to the visual arts. Decisions on each of these categories have been difficult and controversial. Before the first world war, national and municipal museums and galleries were receiving public support but living artists relied - apart from occasional public commissions - mainly on private collectors. After 1946 with the increasingly heavy

Table 8
Expenditure on the Visual Arts: A comparison

	1973/4		1978/9	
	No.	Cost	No.	Cost
Grant aid to Galleries	19	£101,670	21	£660,023
Grants and guarantees towards exhibitions	46	£24,448	38	£68,049
Works of Art for Public buildings	9	£16,700	15	£27,585
Provision of studios	2	£11,959	2	£23,610
Awards to artists		£40,110		£127,446
Awards to Performance artists	12	£18,335	5	£12,665
Gallery improvement and equipment	16	£7,000	13	£13,713

In addition, in 1978/9 there were awards to three artists in residence (totalling £8,300), nine publishers (£12,713) and to ten art magazines (£16,080).

Note: this table does not include expenditure on the Arts Council's own exhibitions or purchases for its collections.

One of many 'temporary exhibitions of original works' at the Serpentine Gallery, London (Arts Council of Great Britain).

incidence of taxation on a formerly prosperous middle class the decline in private support and commissions accelerated. It seemed that some form of support for living artists had to be devised if the artistic life of the country was not to languish.

Many of the Arts Council's advisory panel for art took the view that the best service that could be rendered to an artist was to purchase his work. Therefore the Council decided to form a permanent collection which should represent 'the best in British contemporary art', and at the same time make more widely known the work of younger artists, whose talents were not fully recognised, by forming exhibitions from these purchases and showing them throughout the country. Admirable aims in theory, and in practice effective and useful to artist and public alike. Certainly a lot of good work was bought and a lot of people were given the opportunity to see it, though the effect on sales of artists' work was more questionable.

Of course any body which sets itself up as a judge of what is the best art of its time before time itself has been able to make a judgement is going to walk through a minefield of hostile criticism. Such institutions as the Tate gallery, the British Council and the Arts Council have all at various times been the target for violent, outraged criticism for 'wasting the public's money on rubbish'. True, 'experts' can err.

However, no one to my knowledge has ever suggested a more promising system for selection than that of entrusting the task to those with a passionate and sustained enthusiasm for art. In the Arts Council purchases are made on its behalf by two or three members of the art advisory panel, and these purchasers change annually to avoid risk of too narrow a choice. Naturally, the kind of art such institutions support will depend on the people chosen to select it, and there will always be argument and disagreement on this score.

Criticisms of the Arts Council's choice of contemporary works and of artists to receive support has grown in volume (and bitterness) in recent years; partly no doubt as a result of the increased disaffection of the younger generation for what they call the 'establishment' and all its institutions, but also from the more conservatively-minded who object to the 'outrageousness' of work produced by those artists with a dissident attitude to society.

Some artists will inevitably want to push against the limits of what is publicly acceptable on grounds of obscenity, frivolity or overt political propaganda. This is a perennial problem for an institution such as the Council which depends for its funds on an annual grant-in-aid. The Council (which is not an elected body) is rightly, in my view, jealous of its independence, and therefore sensitive to hostile criticism in Parliament and chary of outraging public opinion. On the other hand its duty to the arts and artists is its prime concern. Many artists are extremely sensitive to any form of restraint or control over what they show under the Council's auspices. The Council staff must steer between angry complaints from the public (usually instigated and encouraged by the popular media) of 'waste of public money on worthless and/or obscene rubbish' and the passionate insistence of artists on total freedom to show whatever they want to show. In theory the best help for this kind of controversy should come from fuller explanation of artists' aims from artists themselves, but in practice not all sorts of artistic goals are easily communicated in simple language.

The British system of giving state aid to the arts through an independent body is sometimes criticised on the grounds that a body of non-elected members is undemocratic and tends to become monopolistic in its patronage. I have never heard inside the Council of any ambition to become a monopolistic dispenser of funds for the arts. On the contrary any spreading of the responsibilities for patronage has always been welcomed; the Regional Arts Associations have a valuable role to play in this area. If it were not for the restrictions attached to accountability for public funds I have little doubt that the Council would welcome

the extension of the principle of self-government to more artists' undertakings.

It is extremely difficult to see how a body such as the Council could consist of elected members. The problem is, and will surely remain, where is the electorate to be found?

In my experience the form of system is often less important than the qualities of those men and women who work it. The Arts Council though it has grown in size is not yet too big to be impervious to change and new ideas.

Robin Campbell C.B.E.

Came to his post by way of possessing both wide experience of the visual arts and unusual international experience; before the war he was Reuter's Correspondent in Berlin and Warsaw. He joined the Arts Council in 1960, was appointed Director of Art in 1969 and served in that capacity until his retirement in 1978.

THE EUROPEAN PERSPECTIVE
John Allen

Readers of the foregoing pages will be under no doubt as to the effectiveness of the Arts Council of Great Britain or the measure of its achievement during the thirty or so years of its existence. The purpose of this final and concluding chapter is to consider briefly what other European countries are doing by way of developing a policy for subsidising the arts. The theatre has been taken as an example but the same principles apply, on the whole, 'across the board'. The countries referred to are Belgium, France, the Federal Republic of Germany, Italy, the Netherlands, Sweden and Switzerland as well, of course, as the United Kingdom. The selection is not arbitrary but related to an independent study of the effect of subsidy on creativity in the theatre, commissioned by the Council of Europe.

The Arts Council provides a convenient point of departure. But it so happens that over the last two or three years the major British political parties together with the Trades Union Congress have published discussion papers on arts policy which it will be convenient to discuss in the same context.

What is the Arts Council? It would perhaps be described in the now fashionable term as a 'quango', a slightly repellant word of such recent (and American) origin that it appears in only the most up-to-date dictionaries. A semi-government body; an independent and self-governing organisation funded by the government, and so in the last resort dependent on government finance and vulnerable to government policy. It is a point which needs to be teased out a little.

Central government has laid down certain guidelines within which the Arts Council must operate. For example, it is debarred from involving itself in education or training for the arts although the logic of the situation is pushing the Council steadily though uncertainly in this direction. If the Council entered into financial commitments with which the controlling government department, in this case the Office of Libraries and the Arts, was not in agreement, its grant would undoubtedly be

in jeopardy. In this sense the Council is a free agent only within permissible areas, and in terms of government policy, even if this policy is largely expressed in financial terms. The Office of Libraries and the Arts continues to control and negotiate on its own account certain other issues such as Public Lending Rights and international copyright agreements.

Let us give an example of what is meant by control through finance. In the early summer of 1979 a Conservative government came to power in Great Britain. One of its early decisions was to cut the grant to the Arts Council by a little over £1 m. for the current year. This action was taken presumably on the basis of declared Conservative policy of reducing both taxation and public spending in order to put more into people's pockets to spend as they wish rather than to have it spent for them by the government.

This was both a negative and an arbitrary act of policy. The current Arts Council grant is in the region of £70 m. It may be asked how this figure was arrived at; what policy does it represent; and the answer is that it represents an annual increase of a fluctuating amount from the original £238,000 of 1947, depending on the generosity of the government in power, to cover both inflation and increasing demands on the Council's support. (For as the foregoing papers make amply clear, the Council has been the victim of its own success and created demands and expectations far beyond any that would have arisen if it had never existed).

But what does £70 m. represent other than being the outcome of an annual 10% increase, or whatever the figure may be, over the last 30 years? Enthusiasts claim that the grant should be doubled. Why doubled? Why not trebled? Or halved, as the present government would doubtless favour? It is ridiculous that the figure should be a statistical accident when it should represent the money that is thought necessary to achieve a certain purpose. The Arts Council knows very well how to apportion its £70 m. even though there are detractors in plenty who think they know better. But the British public has never been favoured with a government statement explaining clearly why it thinks it necessary to spend 45p. per head of population or whatever the 1977-8 figure may have been, on the theatre. Jennie Lee's *A Policy for the Arts* is the sole example of an attempt by a government to explain its policy or initiate a public debate on this important subject. But then Miss Lee, as she then was, was a remarkable women with a most unpolitical passion for the arts, and easy access to the Arts Council as well as the Prime Minister's office.

The theory of public subsidy to the arts is related, but not central

to this chapter. Government responsibility for a range of public services becomes the greater as it controls an increasingly large proportion of national expenditure, in most European countries something in the region of 50%. Some services are taken for granted even though their measure is hotly debated: the armed forces, a judiciary, a state system of education, a postal service, a transport system, an airline, and various amenities of a generally cultural kind. But what is the responsibility of government, both central and local, for culture and the arts? The argument should be more intense because these are aspects of living that touch very closely the private life of every citizen. For culture is the very environment in which we live, the architecture as well as the cleanliness of our streets, opportunities for participation in debating matters of public concern, and therefore our newspapers and broadcasting services, freedom of discussion, of worship, of artistic expression. Interferes a government too vigorously in such intimate and delicate matters and it is accused of 'brainwashing', 'manipulating culture for political ends', or of plain Fascism; it stands aloof and we accuse the politicians of being a gang of Philistines.

'You can't win', grumbles the frustrated politician. 'But you could at least try', we answer testily. For the theory of state support rests on the assumption that the government assists or wholly supports those services and activities which it considers to be a part of the public good, rather like the classical Greek concept of 'liturgy', or public service, but which for one reason or another cannot pay for themselves at a price which makes them reasonably available to a majority of the population. The arts, according to one set of arguments, are particularly vulnerable since they are labour-intensive and cannot increase their output to meet increasing wage demands.

This is not the place, as we have said to argue the problem; it must suffice to postulate its importance and to express surprise that it is not more widely debated. For the fact of the matter is that most European countries are spending fairly considerable amounts of public money on the arts in general and the theatre in particular on a kind of tacit assumption that the arts are good for you. In Sweden and the Federal Republic of Germany, the countries with the most buoyant economies and the highest Gross Domestic Product, the figure is in the region of £6 - £7 per head of population. Even Italy, bottom of the G.D.P. table, spends over £1 per head accountable by the fact that the government subsidises 13 regional opera houses to the tune of some 80,000 m. lira a year (rather more than £50 m.). But comparative figures for subsidy are virtually meaningless owing to greatly differing methods of accountancy, as well

as the problem that in West Germany, for example, where most state theatres stage opera, ballet and drama, no distinction is made in subsidy between the dramatic and the lyric theatre.

And here a word of explanation. We have sometimes referred to total public subsidy, sometimes to central or local government. These distinctions are important. In most countries, especially those with a centralised government, the major source of subsidy is the Exchequer via the Ministry of Culture or its equivalent. It is increasingly the custom for additional subsidy to be available from local authorities, with the town, communes, or municipalities making a very much larger contribution than the regional governments. This opens up an extremely interesting area of study in the fiscal arrangements of the various authorities for raising money and their freedom or otherwise to spend it. The total local government subsidy tends to be somewhere between 30% and 50% of central government. In the two countries with a federal constitution, Switzerland and West Germany, the contribution from the Confederation, in the case of the former, is nil and in the case of the latter, 50m. DM. (c. 25p. per head of population), a negligible contribution compared with that of the Cantone and Gemeinde. Sweden is unique in the very considerable subsidy provided by both central government and the municipalities.

The proposal, therefore, that subsidy should be the outcome of a policy is as applicable to local as to central government and it is astonishing to find the extent to which so serious a matter and one involving such considerable sums of money should be in the hands of administrators functioning within terms of a broad political directive with little evidence of professional advice or democratic discussion.

The only country with an organisation remotely similar to the Arts Council is Sweden with its Kulturradet (Cultural Council). The particular nature of such an organisation takes it colour from its national context and many historical and social pressures impossible to identify. If it lacks the authority of its British counterpart this is perhaps because its position is less vulnerable. One of the more distinctive features of the Swedish form of government is that legislative measures are usually proposed not in the first instance by ministries but by a group of experts forming a commission of enquiry which takes its brief from the minister concerned with the approval of the government. There follows what the Swedes admit to being a time-consuming and cumbersome administrative procedure but it permits a very high degree of democratic consultation.

The National Council for Cultural Affairs was created in 1969 as

a result of a lively cultural debate among practitioners of the arts in the latter part of the decade. In 1973 the Council produced a detailed study of cultural policy in Sweden together with proposals for the future of Kulturradet which was envisaged as carrying out very much the same kind of responsibilities as those at present carried out by the British Arts Council: advice to the government on long-term planning, sifting of demands for subsidy and regional cultural organisations, and so on.

Lord Redcliffe-Maud includes in his *Support for the Arts in England and Wales* an appendix which describes a visit to Sweden and a close study of the National Council for Cultural Affairs. Lord Redcliffe-Maud makes the point that since the Swedes conceive the arts and culture as a very much more integral part of the State's educational responsibility than we do in Britain it is understandable that the Council is more an arm of the government than the British Arts Council is, since there is less divergence of interest. "It is more a question of the government spending its money via the Council than the Council seeking government money to carry out its policies as is the case in Britain". But of the advisory function of the Council and its influence on the whole cultural life of Sweden there can be no question.

There is no other country with a similar organisation, either at national or local level. This is particularly surprising in the case of Switzerland, which is generally agreed to have the most democratic constitution in Europe, and all the more so since in 1975 the Federation sponsored an extraordinarily impressive survey of Swiss cultural policy in *Elements pour une Politique Culturelle en Suisse*. This provides us, in 350 large and closely printed pages, with a detailed description of every aspect of Swiss cultural life written with refreshing candour. It describes the canton of Tessino, Italian-speaking Switzerland, for example, as being so devoid of cultural life as to be in danger of constituting nothing more than a corridor between Zürich and Milan. It also provides a further 100 pages of analysis and suggestions for a general cultural policy. The tenor is thoroughly urbane and civilised. There are no aggressive recommendations that this, that or the other should be done, just a constant insistance on regional responsibility and a gentle reminder that 'almost all the cantonal authorities and most of the communal authorities have been obliged, by circumstances, to form commissions charged with examining cultural problems and even organising cultural institutions'. Enquiries reveal that practice varies. Subsidy is in the hands of the communes or towns. They are not large; Zürich, the biggest, has a population of under one half million; Basle the next biggest, something over 200,000; Bern, the federal capital,

170,000. In these circumstances it is not difficult for the public authorities to keep in touch with the various recipients of subsidy; but when there is need for a commission to consider some particular problem - the report considers the various possible functions of such commissions - there is no difficulty in forming one. Democratic procedures are built in to every aspect of Swiss life.

In the Federal Republic of Germany there are some 217 subsidised theatres and another 80 or so private theatres and a number of touring companies. 40 - 50 of these theatres are subsidised by the states, that is, the Länder or regional governments, the rest by the municipalities (Gemeinde). This rather complex arrangement is the direct result of the political development of the country from the vast network of principalities, dukedoms, duchies and palatinates of the 18th century, some with their own 'state' theatre, to the creation of a federation of states or Länder following the 1939 - 45 war. Although procedures vary slightly in the different states, the usual custom is for the government of each land (Landesregierung), or the City Council, as the case may be, to establish a Ministry (or Department) for Education and Culture where requests for subsidy are first received. Each request is considered by the Minister of Finance who forwards it with appropriate recommendations to the cabinet where it is discussed by a special parliamentary sub-committee in the light of the total allocation of funds available for the theatre. Its recommendations are then forwarded to the Ministerialdirigent who deals directly with the Intendant or Finance officer of the theatre.

In Belgium, Parliamentary decisions are promulgated by means of Royal decree. The Ministries of both Dutch and French-speaking culture pass proposals for subsidy to advisory committees, the composition of which is clearly specified to include both professional experts as well as civil servants. But they have no other responsibility than to give professional advice to the Minister.

The recent history of the Dutch theatre provides an interesting example of what happens when a government department proposes a policy for the theatre without proper consultation. The Dutch theatre has a curious structure based on about 12 mainstream subsidised companies and a number of private companies. In most towns there is a municipal theatre but, except in two or three cases where a company uses a certain theatre as a base, there is none of that close correspondence between company and theatre that exists in most countries. As a result there is a very considerable amount of touring with one, two, or three night 'stands' as the general rule. Several years ago a well-intent

ioned administration in the Ministry of Culture tried to impose upon the country a structure of regional theatres and national coverage; but lack of adequate consultation with the managers involved resulted in the collapse of the scheme. The lesson, however, was learnt and a new and fully developed scheme is now under discussion, with the creation of something roughly equivalent to the Arts Council among the main recommendations.

As for Italy, the reluctance of this lively and inventive people to answer letters or even run an effective postal service has made it difficult to gather as much authoritative information as has been possible elsewhere. The regional situation, moreover, is exceedingly complex owing to the surprising fact that as a result of persistent political instability and the country's deep economic anxieties it has not yet been able to implement the democratic constitution of 1947 and this has left the cities still largely dependent on Rome for their income. But there is a good deal of evidence of considerable theatrical vitality at local and regional level. The emergence over the last few years of between 50 and 60 mainstream co-operative companies has offered a serious challenge to the eight 'stabili' (regional theatres); and regional organisations, many of them with an intensly political complexion, have left no place for the more complacent advisory committee whether functioning at regional or national level.

France has been left until last because procedures for subsidy in this country throw up a number of questions that require further consideration.

France has five so-called 'national' theatres, 19 regional theatres (Centres Dramatiques Nationaux) and upwards of 100 independent companies in receipt of varying amounts of subsidy. All this is administered centrally by the Ministry of Culture in the Rue Saint-Dominique. Subsidy is based on a contract made between the Minister, or his representatives, and the director of the company or theatre that is being subsidised for a three year period. (In Great Britain the cheque is made to the chairman of the board of the theatre in question). The French claim that their procedure gives far more security to the recipient of subsidy than the British procedure, while the three year contract provides an easy escape from unsatisfactory appointments.

One of the major political efforts in Britain and France during recent years has been towards a policy of decentralisation. Regional theatres have been encouraged to establish the closest possible relationships with their local authority. It is a curious fact that what might seem on the surface to be a commonsensical and greatly-to-be-supported policy, has not found favour among theatre directors. So far as theatrical

subsidy is concerned they would rather deal with the official or administrator in 105 Piccadilly or the Rue Saint-Dominique than the local town hall. The reason for this is that the central government administrator tends to be more expert and knowledgeable than the far more loosely constructed bureaucracy at regional level. The officer in the Arts Council or the French Ministry of Culture knows the answers even if the answer is negative.

This is to raise one of the great stumbling blocks to a regional policy for the theatre. In recent years the Council of Europe has given considerable attention to the general subject of the democratisation of the arts. Finn Jor's *The Demystification of Culture*, J. A. Simpson's *Towards Cultural Democracy*, and especially Stephen Mennell's *Cultural Policy in Towns* make a useful contribution to the subject. The last named is a report on the Council's experimental study of cultural development in fourteen European towns. Mr. Mennell's conclusions confirm the anxieties underlying the present paper. Weaknesses arise less from an absence of cultural and artistic activity in the average European town than from the general absence of a proper organisation (in the town hall) to deal with any artistic problem that may arise; the artist finds it impossible to discover on which door to knock. Not only do most European towns lack any kind of professional democratically-constituted advisory committee but their bureaucratic machinery does not establish one committee of the council as responsible for everything that arises concerning the theatre, for example. The English town contributing to the enquiry was Exeter and Mr. Mennell gives an unhappy picture (pages 57 - 59) of the incompetence and incapacity with which the Council handles anything to do with the theatre or with drama, passing one project to one committee, another to another.

In so far as a policy for subsidising the theatre is expressed in the manner in which the money is distributed and then used by the theatre, there do not appear to be any significant differences between one country and another. There is a general subscription to the belief that public money should be used for three main purposes: to maintain or even improve artistic standards; to broaden support for the theatre by using subsidy to control the price of seats and induce more people (and people from a broadening social class) to support the theatre; and to encourage what the French call 'créations', by which they mean the writing and productions of new plays, staging of experimental productions, and a general artistic vitality.

Differences in practice between one country and another emerge, as has been seen, in the amount of money that is provided from public

funds for subsidising the theatre, and the manner in which it is distributed. On the first score, amount is clearly related to policy, whether that policy is clearly articulated or not. Demand can be analysed under a number of headings. The biggest single claimant on subsidy is a national theatre. The British National Theatre and the Royal Shakespeare Theatre received between them in 1976 - 77, 27% of the total Arts Council allocation for the theatre; the Théâtre National de Belgique received 51%; the five French national theatres received 41%; the Swedish Royal Dramatic Theatre, 15%. There are then claims from regional theatres: about 50 in Britain, 19 in France, eight in Italy together with 50 - 60 Co-operative companies, 15 in Sweden, and so on; from touring companies; and from that most contentious area, the alternative theatre, the source in some countries of the most original theatrical work to be found, but rarely 'persona grata' with the politicians and the authorities for the frequent socially critical nature of the material.

The allocation of money between so many different claimants can only be based on a coherent policy if it is to be explicable to anyone. To give a quarter of the total grant to a couple of theatres implies that there must be something very special about these theatres that is worth preserving. This may well be the case; but the taxpayers have the right to know what this is. The large proportion of subsidy granted to the Belgian National Theatre is largely explained by the considerable amount of touring it carries out. The small proportion accorded to the Swedish National Theatre is balanced by a considerable commitment to touring through the Riksteater (over 130 companies in 1978). But no form of theatre challenges the policy-makers to the extent of the alternative theatre which in many cases does try to present an alternative to the mainstream theatre in organisational methods, style of production, and choice of play. It is therefore implicitly radical; and an administration has to accept the point of view that has been strongly proposed by a Swiss critic, that a healthy democracy must not only support but encourage criticisms of its own procedures.

Another categorisation lies in the obvious distinction between the companies that are clearly of a national character and those operating on a regional basis. It is arguable that machinery for subsidising the former should properly be left in the hands of a central administration; but that a central authority is not, on the whole, well-placed to measure the needs and effectiveness of regional activity. So there is strong justification for some such organisations as the British Regional Arts Associations, although it is clear that if such an association is to be regional in substance as well as in name, it must be in a position to draw at any rate

a substantial amount of its funds from regional or local sources, that is to say the local, regional or municipal authority which alone has the capacity to raise money from the inhabitants of its area.

It must be repeated that this is not the place to argue the effectiveness or otherwise of the Arts Council as at present constituted as a central national organisation, or the Regional Arts Associations; but it seems to be a matter of principle that either through the democratic procedures of the town hall, or through some para-bureaucratic regional arts association, there should be a close professional link between the authorities with money to dispense and the recipient organisations.

The Council of Europe has been particularly concerned with the democratic aspect of the process. J. Goldberg and P. Booth in *Décentralisation de la Promotion Culturelle* (Strasbourg, 1976) have argued strongly that:

'in cultural matters organisations should be decentralised, dynamic, independent, flexible, and to a reasonable extent democratic. No organisation alone can meet all these criteria but we have shown in connection with the financing of theatres that it is necessary to set up a regional or provincial authority between central government and local administration and to give it real power.'

The matter was vigorously taken up in the autumn of 1977 by the whole group of French theatrical unions, *Le Syndicat National des Cadres Techniques, Administratifs et Artistiques du Spectacle*, (SNC TAS) who demanded that workers in every sector of cultural activity should have a voice in the framing of policy. They proposed among their more practical demands that there should be developed a more flexible arrangement for subsidising the national theatres with a redefinition of their objectives (mission propre), a recognition of the individual requirements of the 19 Centres Dramatiques Nationaux (which tended to be administratively lumped together), that proposals for half-a-dozen national children's theatre centres should be immediately implemented and that, on the whole, theatrical subsidy should be index-linked.

The Council of Europe also publishes a collection of essays *Explorations in Cultural Policy and Research* edited by Stephen Mennell, (Strasbourg, 1978) which includes an essay entitled *Seven Mortal Sins in Swedish Cultural Policy*. Some of these 'sins' will be familiar to critics of the British arts establishment: irrelevant concepts of culture; too great a concern with standards of performance among professional artists; too close an identification of self-expression with inherited forms of art and traditional structures in plays, canvases, concerts, novels etc.; the assumption that high art is created in the cities and then port-

ioned out to the country by a benevolent bureaucracy; too great an assumption that education alone is sufficient to destroy the existing cultural elitism; and the ready assumption that the art now being produced and distributed is the most significant art of the day. And so on.

Many people will brusquely reject these rather cavalier and perhaps excessively radical suggestions. But it would be dangerous to do so without recognising the crucial importance of the relationship between inherited art and a living, vibrant contemporary culture. Few people in their right mind will question the value of Greek art of the classical period, medieval ecclesiastical art or the humanist art of the Renaissance and 17th century; but it is arguable that we cannot wholly live on such an inheritance; for art is a living quality, the response of highly articulate men and women to their environment. Many people may not derive as much pleasure from the paintings of Picasso as from those of Leonardo, from the music of Stockhausen as from that of Beethoven; but Picasso and Stockhausen and hundreds of little-known painters, poets and musicians are as crucial for the vitality of a society as the art it has inherited; arguably, more.

We have already referred to a number of discussion documents that have recently been produced by the various political parties. None of them makes the heart beat faster. On the whole there is support both for the Arts Council, coupled with a plea for greater initiative by central government, as well as for some form of regional arts associations. But there is a widespread feeling extending beyond the present documents, that the Arts Council should be democratised. In the view of the Labour Party and the T.U.C. this should be achieved by including in the advisory panels official representatives of professional organisations. This is a perfectly logical point of view. But anyone who has had experience of these things will know that the official representative is chosen for a variety of reasons, such as reward for long service or a reputation for playing safe, but rarely on account of the lively individual contribution he is likely to make to discussion. The present system by which the panels represent a cross-section of specialists known for their individuality and enthusiasm are unfairly represented in the Liberal Party's report as 'an elitist corps of art advisers . . . masquerading under democratic disguise'. But the Liberals then try to have the best, or as it may be, the worst of both worlds by proposing the replacement of the Council as at present constituted by an Arts Development Board, the members of which should be elected through and representative of the major bodies concerned with the arts. The Conservative discussion paper makes few concrete proposals, which is just as well since the Conservative

Government, after several months in office, have shown little interest in the arts, except to cut the subsidy on which they subsist.

Extraordinarily inadequate though these discussion documents appear to be, they are not as depressing in themselves as the fact that they have led to virtually no discussion. And without discussion the arts sustained by public subsidy can play a hardly more significant role in contemporary society than bread and circuses did in the declining years of the Roman Empire. Art, cry the enthusiasts, is not the icing on the cake but the yeast in the bread. The arts make the most significant contribution to the culture within which we live. If that culture is not to be imposed by the bureaucracy we must insist upon participation. Georges Pompidou is reported by Alain Peyrefitte (in *Le mal Francais* - Plon, 1976) as having described participation as 'the revitalisation of society'. One could easily call it, he goes on to say, 'decentralisation'.

The truth of the matter appears to be that initiative must come both from the top and the bottom, from the will of central government to apportion its credits with care, with forethought and within a clearly determined policy; from the will of the people, expressed through the smallest social groupings such as a parish council in collaboration with the larger regional authorities, to involve themselves in the creation of their own local culture even though it may include elements of larger surrounding, and even national, culture. As J. M. Synge says in the preface to his plays, 'a people is unlikely to be able to build cathedrals if it shows no regard for ordinary dwelling houses'. If the average European housing estate or tower block is a projection of the official mind or a reflection of what a social democracy will accept as a tolerable dwelling house, it is small wonder that we look on Homer, Dante, Shakespeare and the Bible as the achievements of a race of gods.

John Allen C.B.E.

Visiting Professor at Westfield College, London, has been astonishingly successful in each of his many careers. After the war until 1951 he was Director of Glyndebourne Children's Theatre. Then followed ten years as a writer and producer with the B.B.C. and from 1961 to 1972 he was H.M. Inspector of Schools with a particular concern for Drama. His great influence on the development of educational drama continued when he was Principal of Central School of Speech and Drama from 1972 to 1978. He has served on many Arts Council and other panels, has published several books, and has in recent years been studying methods of subsidy throughout Europe. His book on that study will be published in 1981.

Appendix 1

OFFICERS OF THE ARTS COUNCIL

Years	Secretary General	Deputy Secretary General	Assistant Secretary General	Finance (Various titles)
1946–1950	Mary Glasgow		Eric Walter White	E. L. Horn (Accounting Officer)
1951–1955	Sir W. E. Williams	M. J. McRobert		D. P. Lund (Finance Officer)
1956–1963	Sir W. E. Williams	M. J. McRobert (Also Finance Officer 1956-71)		(Accountant when M. J. McRobert became Finance Officer)
1964–1967	N. J. Abercrombie	(Also Finance Officer 1956-71)	(Also Literature Director 1966-71)	
1968–1970	Sir Hugh Willatt		(Also Literature Director 1966-71)	Anthony Field (Accountant)
1971–1974	Sir Hugh Willatt	Angus Stirling		(Finance Director)
1975–1979	Sir Roy Shaw	Richard Pulford		

141

	Drama Director	Music Director	Art Director	Literature Director	Director of Regional Development	Director of Touring
1946	Michael MacOwen	Steuart Wilson	Philip James			
1947	Llewellyn Rees*					
1948		John Denison				
1949	John Moody					
1950						
1951						
1952						
1953						
1954	J. L. Hodgkinson					
1955						
1956						
1957						
1958			Gabriel White			
1959						
1960						
1961						
1962						
1963						
1964						
1965		John Cruft		Eric Walter White		
1966						
1967						
1968						
1969						
1970	N. V. Linklater		Robin Campbell			
1971				Charles Osborne		
1972						
1973						
1974						
1975					Neil Duncan	Jack Phipps
1976						
1977	J. R. Faulkner		Joanna Drew			
1978						
1979						

* Charles Landstone held the post of Associate Drama Director from 1947 to 1952, while acting also as General Manager of the Bristol Theatre Royal.

142

Appendix 2

THE OPERATING COSTS OF THE ARTS COUNCIL

The accusation is sometimes made that money which should go to artists goes instead on unwieldy administrative costs. The following gives the picture as it relates to the direct expenditure of the Arts Council, and the Scottish and Welsh Arts Councils.

1 By "general operating costs . . ." the Arts Council means:

Salaries and wages, superannuation, travelling and subsistence, rent, rates, heat, light, post, phone, stationery and printing, professional fees, **enquiries, investigation and research,** office and sundry expenses, **publicity** and **entertainment.**

2 The Council's Grant in Aid of

	1975-76	1976-77	1977-78	1978-79	1979-80
	£28,850,000	37,150,000	41,725,000	51,800,000	63,125,000
was increased by: fallback	88,000	125,000	208,000	153,000	121,000
and interest etc.	146,000	145,000	86,000	159,000	292,000
to a total available of	29,084,000	37,420,000	42,019,000	52,112,000	63,538,000

of this

S.A.C. got	3,100,000(11%)	4,535,000(12%)	5,029,000(13%)	6,183,000(12%)	7,661,000(12%)
W.A.C. got	2,403,000(8%)	2,873,000(8%)	3,280,000(8%)	3,938,000(8%)	4,580,000(7%)
leaving, for England,	23,581,000(81%)	30,012,000(80%)	33,710,000(79%)	41,991,000(81%)	51,297,000(81%)

Of this,

spent on the arts:	22,338,000(94%)	28,485,000(95%)	32,202,000(96%)	39,971,000(95%)	48,614,000(95%)
spent on operating costs:	1,095,000(5%)	1,243,000(4%)	1,420,000(4%)	1,775,000(4%)	2,232,000(4%)

Note: The 5% or just under shown to be spent on "operating costs" is the cost of handling grants in England as well as of allocating grants to SAC and WAC - "headquarters costs".

3 The Scottish Arts Council's grant was

	1975-76	1976-77	1977-78	1978-79	1979-80
	£3,100,000	4,535,000	5,029,000	6,183,000	7,661,000
and increased by: fallback	15,000	27,000	30,000	53,000	76,000
and interest etc.	15,000	78,000	20,000	18,000	35,000
to a total available of	3,130,000	4,640,000	5,079,000	6,254,000	7,772,000

Of this,

spent on the arts:	2,831,000(90%)	4,294,000(93%)	4,718,000(93%)	5,851,000(94%)	7,344,000(94%)
spent on operating costs:	257,000(8%)	256,000(6%)	296,000(6%)	363,000(6%)	401,000(5%)

4 The Welsh Arts Council's grant was

	1975-76	1976-77	1977-78	1978-79	1979-80
	£2,403,000	2,873,000	3,280,000	3,938,000	4,580,000
was increased by: fallback	3,000	13,000	26,000	8,000	9,000
and interest etc.	22,000	22,000	8,000	26,000	37,000
to a total available of	2,428,000	2,908,000	3,314,000	3,972,000	4,626,000
Of this,					
spent on the arts	2,178,000(90%)	2,624,000(90%)	3,009,000(91%)	3,625,000(91%)	4,193,000(91%)
operating costs	185,000(8%)	219,000(8%)	286,000(9%)	311,000(8%)	339,000(7%)

5 By adding together for England, for Scotland, and for Wales, the totals spent "on the arts" and "on operating costs" can be found.

	1975-76	1976-77	1977-78	1978-79	1979-80
Total Grant in Aid	£28,850,000	37,150,000	41,725,000	51,800,000	63,125,000
Amount spent					
on the arts	27,347,000(94%)	35,403,000(94.6%)	39,929,000(95.7%)	49,447,000(95.5%)	60,151,000(95.3%)
operating costs	1,537,000(5.2%)	1,718,000(4.6%)	2,002,000(4.8%)	2,449,000(4.7%)	2,972,000(4.7%)

Notes: All these figures exclude transfers to or from Capital Accounts. In the five years shown, these have been small.

Figures are taken from the relevant ACGB annual accounts.

Percentages may not add precisely to 100% because of
 a) rounding
 b) the omission of capital account figures.

The conclusion is that less than 5% of the total grant goes in 'general operating and administrative costs' at the Council's headquarters.

However it is not true to say that 95% of the Government Grant in Aid is therefore spent 'on the arts'. Many of the Arts Council's clients have themselves considerable further administrative costs. For example in 1977/78 the Greater London Arts Association spent 29% of its total expenditure on operating costs, a figure which was 49% of its Arts Council Grant. Thus the clients of G.L.A.A. - most of whom have **further** administrative costs - actually receive a grant which has, arguably, been slimmed already by more than 30% adminstrative costs.

Appendix 3

COMPARATIVE PROGRAMMING

1 BIRMINGHAM REP.

1948

The Damask Cheek - John Van Druten and Lloyd Morris
Let the People Live - Bernard Lytton Jaeger
The Second Mrs. Tanqueray - A. W. Pinero
Peer Gynt - Henrik Ibsen
The Rivals (modern dress) - R. B. Sheridan
The Merchant of Yonkers - Thornton Wilder
Jonathan Wild - Fielding adapted by Barry V. Jackson
Mourning Becomes Electra - Eugene O'Neill
The Comedy of Errors - William Shakespeare
The Bears of Bay-Rum - Barry V. Jackson from a play by Scribe; music by Offenbach

1958

Macbeth - William Shakespeare
The Teahouse of the August Moon - John Patrick
Dagger's Point - Joseph O'Conor
The Curious Savage - John Patrick
Hedda Gabler - Henrik Ibsen
The Potting Shed - Graham Greene
A Dead Secret - Rodney Ackland
Three Elizabethan Rarities - (Authors uncertain) Johan Johan, the Husbande, Tyb,
His Wife, and Syr Johan, the Preest; A Yorkshire Tragedy; and Fratricide Punished.
Fear Came To Supper - Rosemary Anne Sisson
When We Are Married - J. B. Priestley
The Royal Astrologers - Willis Hall

1968

Othello - William Shakespeare
Romeo and Juliet - William Shakespeare
St. Joan - Bernard Shaw
After the Rain - John Bowen
Beware of the Dog - Gabriel Avout.
Investigation - Leslie Sands
White Liars & Black Comedy - Peter Shaffer
The Merchant of Venice - William Shakespeare
Old Time Music Hall
The Rose and the Ring - John Dalby

1978

Othello - Shakespeare
Hay Fever - Noel Coward

The Servant Of Two Masters - Goldoni
Rosencrantz And Guildenstern Are Dead - Tom Stoppard
She Stoops to Conquer - Oliver Goldsmith
The Merchant - Arnold Wesker
Kiss Me Kate - Cole Porter & Sam Spewack
Babes In The Wood

2 NOTTINGHAM PLAYHOUSE

1948

Man And Superman - Bernard Shaw
Othello - William Shakespeare
You Can't Take It With You - Moss Hart & George S. Kaufman
The Arabian Nights - Bridget Boland
The Torchbearers - George Kelly
Guilty - Emile Zola adapted by Kathleen Boutall
Twelfth Night - William Shakespeare
The Long Mirror - J. B. Priestley
Frieda - Ronald Millar
The Romantic Young Lady - M. Sierra
Tobias And The Angel - James Bridie
Shadow And Substance - Paul Vincent Carrol
The Apple Cart - Bernard Shaw
Caste - T. W. Robertson
The Winslow Boy - Terence Rattigan
The Merchant of Venice - William Shakespeare
The Light Of Heart - Emlyn Williams
By Candle Light - Harry Graham
The Importance Of Being Earnest - Oscar Wilde
Dangerous Corner - J. B. Priestley
Pygmalion - Bernard Shaw
Arms And The Man - Bernard Shaw
Mrs. Warren's Profession - Bernard Shaw
Present Laughter - Noel Coward
The Guinea Pig - Warren Chetham Strode
Bill of Divorcement - Clemence Dane
Treasure Island - R. L. Stevenson adapted by R. Williams

1958

Henry V - William Shakespeare
The Perfect Woman - Wallace Geoffrey and Basil Mitchell
Three Sisters - Anton Chekhov
Our Town - Thornton Wilder
Summer Of The Seventeenth Doll - Ray Lawler
She Stoops To Conquer - Oliver Goldsmith
The Moon Is Blue - F. Hugh Herbert
The Rainmaker - N. Richard Nash
Doctor In The House - Ted Willis, based on the novel by Richard Gordon
Lucky Day - Serge de Boissac
On The Spot - Edgar Wallace
The Banbury Nose - Peter Ustinov
Spider's Web - Agatha Christie

146

Boys, It's All Hell! (The Long and The Short and The Tall) - Willis Hall
Fanny's First Play - George Bernard Shaw
A Memory Of Two Mondays - Arthur Miller
A Resounding Tinkle - N. F. Simpson
Peer Gynt - Ibsen
French Without Tears - Terence Rattigan
The Potting Shed - Graham Greene
The Solid Gold Cadillac - Howard Teichmann and George S. Kaufman
Towards Zero - Agatha Christie
The Black Arrow - R. L. Stevenson. Adapted by J. Blatchley and W. Hall

1968

Tinker's Curse - William Corlett
All's Well That Ends Well - William Shakespeare
Boots With Strawberry Jam - John Bankworth & Benny Green
Skyvers - Barry Reckord
Staircase - Charles Dyer
Dandy Dick - Arthur Wing Pinero
A Midsummer Night's Dream - William Shakespeare
The Little Mrs. Foster Show - Henry Livings
Mother Courage - Bertolt Brecht
Vacant Possession - Maisie Mosco
Candida - Bernard Shaw
Confession At Night - Alexei Arbuzov
King John - William Shakespeare
The School For Scandal - Richard Brinsley Sheridan
Close The Coal House Door - Alan Plater
The Ruling Class - Peter Barnes
The Seagull - Anton Chekhov
Whoops-A-Daisy - Keith Waterhouse & Willis Hall
The Mountain King - Ferdinand Raimund

1978

The Alchemist - Ben Jonson
Shadow of a Gunman - Sean O'Casey
Deeds - Howard Brenton, Ken Campbell, Trevor Griffiths, David Hare, John McGrath
Macbeth - Shakespeare
Vieux Carre - Tennessee Williams
Kiss Me Kate - Cole Porter & Sam Spewack
The Devil's Cut (Mats: Roundabout Co.)
Funny Peculiar - Mike Stott
Around The World In 80 Days - Musical
Sleuth - Anthony Shaffer
Henry V - Shakespeare
Jumpers - Tom Stoppard
The Strongest Man In The World - Barry Collins
The Caretaker - Harold Pinter
The Beaux Strategem - Farquhar
Santa's Wild West Show - (Mats: Roundabout Co.)
Lewis Carroll's Alice

1948

Swiss Family Robinson - Barry Jackson, R. H. Baptist
The Silver Cord - Sidney Howard
The Second Mrs. Tanqueray - Arthur W. Pinero
Tobias and the Angel - James Bridie
Jane Eyre - Adapted by Barbara Burnham
The Guinea-Pig - Warren Chetham-Strode
An Inspector Calls - J. B. Priestley
The Eagle Has Two Heads - Jean Cocteau, adapted by Ronald Duncan
Macbeth - William Shakespeare
Dandy Dick - Arthur W. Pinero
Cinderella - V. C. Clinton Baddeley

1958

Cats and Dogs - John Jowett
I Killed The Count - Alec Coppel
Silver Wedding - Michael Clayton Hutton
The Summer of the Seventeenth Doll - Ray Lawler
Dark Victory - George Brewer Jnr. and Bertrum Bloch
The Anonymous Lover - Vernon Sylvaine
The House By The Lake - Hugh Mills
Sganarelle & The Slave Of Truth - Moliere, adapted by Miles Malleson
The Importance of Being Earnest - Oscar Wilde
Message For Margaret - James Parish
Teahouse Of The August Moon - John Patrick
Towards Zero - Agatha Christie
Worm's Eye View - R. F. Delderfield
Odd Man In - Robin Maugham
The Waltz Of The Toreadors - Jean Anouilh
Nude With Violin - Noel Coward
The Love Match - Glenn Melvyn
Subway In The Sky - Ian Main
The Happy Man - Hugh and Margaret Williams
Sweet Madness - Peter Jones
The Potting Shed - Graham Greene
Intent To Murder - Leslie Sands
The Private Prosecutor - Thomas Wiseman
Hindle Wakes - Stanley Houghton
We Must Kill Toni - Ian Stuart Black
The Chalk Garden - Enid Bagnold
Akin To Love - Peggy Simmons
Charley's Aunt - Brandon Thomas
Sailor Beware - Philip King and Falkland Cary
Anastasia - Marcelle Maurette, adapted by Guy Bolton
Dry Rot - John Chapman
Flare Path - Terence Rattigan
The Bride And The Bachelor - Ronald Miller
Dear Delinquent - Jack Popplewell
Touch It Light - Robert Sharrow
Another Part Of The Forest - Lillian Hellman
Gwendoline - Geoffrey Lumsden

Little Women - Louisa M. Alcott, adapted by Marian de Forest
Murder When Necessary - Philip Levene
Blood Orange - Hugh Hastings
Rookery Nook - Ben Travers
Rogue Prince - Lyndon Brook
Where The Rainbow Ends - Clifford Mills and John Ramsay
Cinderella - Henry Marshall

1968

Robinson Crusoe - Henry Marshall
Under Milk Wood - Dylan Thomas
Green Julia - Paul Ableman
Irma La Douce - Alexandre Breffort
England's Jane - Richard Digby Day
Chips With Everything - Arnold Wesker
The Farmer's Wife - Eden Phillpots
Red Noses For Me - Charles Lewsen
The Good Old Days - Music Hall
The Zoo Story and The American Dream - Edward Albee
The Hollow Crown - John Barton
Say Who You Are - Keith Waterhouse, Willis Hall
The Importance Of Being Oscar
Three To One On - John Gould and David Wood
Relatively Speaking - Alan Ayckbourn
Wait Until Dark - Frederick Knott
The Prime Of Miss Jean Brodie - Jay Presson Allen
The School For Scandal - R. B. Sheridan
Alfie - Bill Naughton
The Proposal - Anton Chekhov
The Dumb Waiter - Harold Pinter
Loot - Joe Orton
Fumed Oak - Noel Coward
Black Comedy - Peter Shaffer
A Day In The Death Of Joe Egg - Peter Nichols
Babes In The Wood - Henry Marshall

1978

Dick Whittington - Henry Marshall & Chris Littlewood
Journey's End - R. C. Sherriff
The Glass Menagerie - Tennessee Williams
Oxford Playhouse Company - Browning Version. Rattigan
Jumpers - Tom Stoppard
Gimme Shelter - Barrie Keefe
Gilgamesh! - Chris Littlewood
Krapp's Last Tape and The Zoo Story - Samuel Beckett, Edward Albee
Blithe Spirit - Noel Coward
Waiting for Godot - Samuel Beckett
The City Waites
Once In a Green Moon - Kurt Weill (7 Deadly Sins, Mahogany and Broadway Songs)
Sooty's In Town
Hinge and Bracket
Colonial Boy

On Approval - Frederick Lonsdale
Jack Shepperd - Ken Campbell
Brief Lives - John Aubrey, adapted by Patrick Garland
Under The Greenwood Tree - Thomas Hardy, adapted by Patrick Garland
Much Ado About Nothing - William Shakespeare
Who's Afraid of Virginia Woof? - Edward Albee
Shadow Play - Winston Graham
Hitting Town and Plugged Into History - Stephen Poliakoff, John McGrath
Kemp's Jig - Traditional
The Bed Before Yesterday - Ben Travers
Florence Nightingale - John Bowen
Husbands and Lovers - Ferenc Molnar
Blind Date - Frank Marcus
Mother Goose - Henry Marshall & Chris Littlewood

4 THORNDIKE THEATRE, LEATHERHEAD

1952

The Wind And The Rain - Merton Hodge
The Shining Hour - Keith Winter
Love In Idleness - Terence Rattigan
Day For Happiness -
Grand National Night - Dorothy & Campell Christie
Dear Brutus - J. M. Barrie
By Candlelight - Siegfried Geyer
Worm's Eye View - R. E. Delderfield
The Intruder - Francois Mauriac
Maria Marten - Anon
The White Sheep Of The Family - L. du Garde Peach
I Have Been Here Before - J. B. Priestley
Buckie's Bears - E. Fay & H. Buffkins
Fallen Angels - Noel Coward
The Witness For The Defence - A. E. W. Mason
Without The Prince - Philip King
A Phoenix Too Frequent - Christopher Fry
& The Browning Version - Terence Rattigan
Don't Listen Ladies - Sacha Guitry
Round The Bend
Invitation To A Voyage - J. J. Bernard
My Wife's Family - H. Stephens & H. B. Linton
Robert's Wife - St. John Ervine
The Case Of The Frightened Lady - Edgar Wallace
Follow The Plough - R. F. Delderfield
The Middle Watch - Ian Hay & S. King Hall
The Fourth Wall - A. A. Milne
Queen Elizabeth - H. R. Williamson
Figure Of Fun - Andre Roussin
The Dover Road - A. A. Milne
The River Line - Charles Morgan
White Cargo - I. V. Simonton
Here We Come Gathering - P. King & A. Armstrong

1958

Blithe Spirit - Noel Coward
See How They Run - Philip King
Towards Zero - Agatha Christie
The Summer of the Seventeenth Doll - Ray Lawler
Miss Mable - R. C. Sherriff
Odd Man In - Claude Magnier
All My Sons - Arthur Miller
Janus - Carolyn Green
Nude With Violin - Noel Coward
Dear Delinquent - Jack Popplewell
The Chalk Garden - Enid Bagnold
Dry Rot - John Chapman
The Voysey Inheritance - Harley Granville-Barker
Picnic - William Inge
Straw In The Wind - Frank Baker
The Bride And The Bachelor - Ronald Miller
Dinner With The Family - Jean Anouilh
Any Other Business - George Ross & Campbell Singer
The Potting Shed - Graham Greene
Variation On A Theme - Terence Rattigan
A Touch Of The Sun - N. C. Hunter
Touch It Light - Robert Sharrow
Death Of A Salesman - Arthur Miller
The Winslow Boy - Terence Rattigan
Nap Hand - Vernon Sylvaine & Guy Bolton
Speaking Of Murder - Audrey & William Roos
Yes And No - Kenneth Horne
Mother Goose - John Crocker
Sailor, Beware - Philip King & Falkland Carey
Hippolytus - Euripedes
Something To Hide - Leslie Sands
Cat On A Hot Tin Roof - Tennessee Williams
Gigi - Colette & Anita Loos
The Dock Brief & What Shall We Tell Caroline? - John Mortimer
The Man - Mel Dinelli
The Elder Statesman - T. S. Eliot
The Shoemakers Holiday - Thomas Dekker
George Dillon - J. Osborne & Anthony Crieghton
A Ticklish Business - Ronald Millar

1968

The Promise - Arbuzov
The Sport of Kings - Ian Hay
A Piece of Cake - Joyce Rayburn
Relatively Speaking - Alan Ayckbourn
The Fan - Carlo Goldoni
Wait Until Dark - Frederick Knott
Grass Roots - Gretchen Cryer
A Doll's House - Ibsen
The Time of the Cuckoos - Arthur Laurents
Mother Goose - John Crocker
The Heiress - Ruth & Augustus Goetz
Spring And Port Wine - Bill Naughton
Trelawny of the Wells - Arthur Pinero

1978

Tartuffe - Moliere
The Norman Conquests - Alan Ayckbourn
Dracula - Charles McKeown
The Kingfisher - William Douglas Home
Donkey's Years - Michael Frayn
Travesties - Tom Stoppard
The Roman Road Show - Joan Macalpine and Peter Durrent
Side By Side By Sondheim
The Babes in the Wood - John Moffatt
Bedroom Farce - Alan Ayckbourn
The Strange Affair of Charles Bravo - Ken Taylor
Fallen Angels - Noel Coward
Antony and Cleopatra - Shakespeare
Barefoot in the Park - Neil Simon
The Little Foxes - Lillian Hellman
Ask Me No Questions - Derek Benfield
Two for the See-Saw - William Gibson
Our Kindness to Five Persons - Tom Gallacher
Small Change - Peter Gill
Abigail's Party - Mike Leigh

Appendix 4

The following gives an indication of changes of programming in three supported theatres between the 'repertory' programmes of the fifties and early sixties, and the more complicated system in operation today.

Formerly the resident company played through the season in repertory. Now it is more usual for the 'Main House' to operate a repertoire system (keeping two or three plays in the schedules and alternating them over a week or fortnight) or, more commonly still, to play for three or even four weeks, and for the Studio theatre to concentrate upon modern, or experimental, works. The present programme is further complicated by the 'one night stands' bought in, by the fringe programme of music, poetry reading, lectures and workshops and by 'lettings'. For example in Sheffield's programme some 30% of events are incoming tours, one-night stands and events such as Snooker Championships which the theatre hosts; none of these is shown in the following lists.

The reader must however form his or her own judgement about the overall value of the present programme, but whatever the judgement on the plays the buildings themselves are now day-long centres for all kinds of community activity.

SHEFFIELD

Presented in 1951/2

The Happiest Days of Your Life
The Holly and the Ivy
Mr. Gillie
Man & Superman
The Little Foxes
Crime Passionnel
Treasure Hunt
Return to Tyassi
The Princess and the Swine Herd
The Taming of the Shrew
Who Goes There
The Cocktail Party

September Tide
By Candlelight
Mrs. Dane's Defence
Queen Elizabeth Slept Here
Black Chiffon
Ring Round the Moon
His Excellency
Figure of Fun
First Person Singular
Caroline
The Biggest Thief in Town

Presented in the Main House in 1978/9

The Second Mrs. Tanqueray
Otherwise Engaged
Celestina
Recruiting Officer
Chicago
Maria Marten
Bedroom Farce
House of Dreams
Much Ado About Nothing
Candida

Presented in the Studio in 1978/9

First Blush
Sawn Off At The Knees
East of the Sun, West of the Moon
The Love of a Good Man
The Myth Dimension
Talent
Psy-Warriors
A Rite Kwik Metal Tata
The Temple of Reason in Truelove's Gutter
The Archangel Michael
Final Wave

COLCHESTER

Presented in the Main House in 1952/3

Quiet Wedding
The Day's Mischief
Arsenic & Old Lace
The Seventh Veil
Heartbreak House
Murder On The Nile
Not Proven
The Cocktail Party
It Won't Be a Stylish Marriage
Rain
The Biggest Thief in Town
Mrs. Inspector Jones
Count Your Blessings
Ring Round the Moon
While Parents Sleep
The Corn Is Green
Smilin' Through
The Ballet Rambert
The Big Window
Easy Money
The White Sheep of the Family
Hobson's Choice

Master Crook
The Three Sisters
The Hollow
Johnny Belinda
Worm's Eye View
Figure of Fun
The Little Foxes
Wishing Well
Why Not Tonight
Springtime for Henry
Gaytime
The Happy Prisoner
School for Spinsters
Short Story
The Same Sky
The Young In Heart
A Priest in the Family
Waggonload of Monkeys
Lady Windermere's Fan
The Wind and the Rain
Ten Minute Alibi
The Seventh Veil

Presented in the Main House in 1978/9

Puss in Boots
Bedroom Farce
Charley's Aunt
Something's Afoot
Worm's Eye View
Comedians
Just Between Ourselves
The Rover
Side by Side by Sondheim (Plus four 'bought-in' tours)

Presented in the Studio 1978/9

Small Change
Old World
Mirrors
About Your Lodger
Only the Bull can Lose
In Darkest Africa
Stevie (Plus three visiting companies)

BRISTOL

Presented in the Theatre Royal 1963/4

An Angel Comes to Babylon
The School for Scandal
A Severed Head
Hullabaloo
The Physicists
The Rivals
The Golden Rivet
Ironhand
Heartbreak House
Around the World in Eighty Days
All in Good Time
The Successor
Othello

Presented in the Little Theatre 1963/4

The Importance of Being Earnest
The Private Ear and the Public Eye
The Pavilion of Masks
Twelfth Night
Semi-Detached
Dial M for Murder
A Christmas Carol
Beyond the Fringe
The Keep
The Gentle Avalanche
Beebee Fenstermaker
Busman's Honeymoon

Presented in the Theatre Royal in 1978/9

Time and the Conways
Cabaret
The Shoemakers' Holiday*
Polly*
Major Barbara*
The Seagull
As You Like It
The Changeling
The Man Who Came to Dinner
Jack and The Beanstalk
Destiny (Plus one major tour)
Love for Love

Presented in the New Vic in 1978/9

Titus Andronicus
The Moon and the Woodshed and Recuerdos
Magnificence
Sexual Perversity and Counting the Ways
The Insect Play*
Ashes
Semi-Detached
Kemp's Days
The Glass Menagerie
Bingo

Presented in the Little Theatre in 1978/9

Arms and the Man
A Man for all Seasons
Loot
Relatively Speaking
Under Milk Wood*
While the Sun Shines
Sweeney Todd

*Bristol Old Vic Theatre School

The programmes can be matched with the changed running costs of the three companies, which can be found in Table 5.

Appendix 5

Further Reading: General

Williams, Raymond **Culture and Society 1780 - 1950** (Penguin 1961)
 The Long Revolution (Penguin 1965)

Minihan, Janet **The Nationalisation of Culture** (Hamish Hamilton, 1977)

Harris, J. S. **Government Patronage of the Arts in Great Britain** (Chicago 1970)

Evans, Ifor and Glasgow, Mary **The Arts in England** (Falcon Press, 1947)

White E. W. **The Arts Council of Great Britain** (Davis Poynter, 1945)

Reports and Surveys

H.M.S.O. **Government and the Arts in Britain** (1958)
 Government and the Arts (1964)
 A Policy for the Arts (1965)
 The Promotion of the Arts in Britain (1975)

Gulbenkian Foundation
 Help for the Arts (Lord Bridges, 1959)
 Support for the Arts in England and Wales (Lord Redcliffe-Maud, 1976)
 The Arts Britain Ignores (Naseem Khan, 1976)

Arts Council of Great Britain
 Annual Reports (1946 - 1979)

Radical Suggestions for Change

Labour Party **The Arts and the People** (1977)
Liberal Party **Change and Choice** (John Elsom, 1978)
Kingsley Amis **An Arts Policy?** (1979)
John Pick **The Privileged Arts** (1979)

Index

157

158